Images of Modern America

PHILADELPHIA
TROLLEYS
FROM SURVIVAL TO REVIVAL

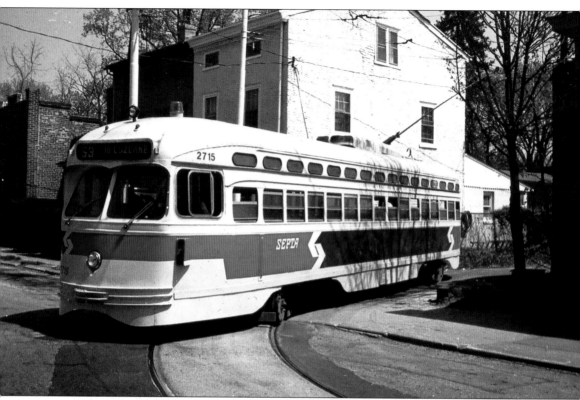

In 1979, the Southeastern Pennsylvania Transportation Authority chose car 2715, a veteran with three decades of service under its belt, to be the pilot vehicle for a new overhaul program. It was retired after eight years, and in 1992, it was sold to San Francisco, where it still serves the public, as seen on page 85. (Courtesy of Harry Donahue.)

FRONT COVER: Kawasaki Heavy Industries light-rail vehicle 9000 stands in the doorway of Woodland Depot, located in southwest Philadelphia, in March 1981. (Courtesy of Ralph Curcio via Daniel McFadden.)

UPPER BACK COVER: Battered car 2592 is seen at Rising Sun and Olney Loop in 1976. (Courtesy of Ralph Curcio via Daniel McFadden.)

LOWER BACK COVER (from left to right): A former Philadelphia Suburban car outside 69th Street Terminal (Courtesy of Daniel McFadden), city trolley in Bicentennial paint scheme at Luzerne Depot (Courtesy of Daniel McFadden), a light-rail vehicle picks up passengers on Woodland Avenue (Photograph by author)

Images of Modern America

PHILADELPHIA TROLLEYS
FROM SURVIVAL TO REVIVAL

Roger DuPuis II

ARCADIA
PUBLISHING

Published by Arcadia Publishing
Charleston, South Carolina

Printed in the United States of America

Library of Congress Control Number: 2016953539

For all general information, please contact Arcadia Publishing:
Telephone 843-853-2070
Fax 843-853-0044
E-mail sales@arcadiapublishing.com
For customer service and orders:
Toll-Free 1-888-313-2665

Visit us on the Internet at www.arcadiapublishing.com

This book is dedicated to the memory of Ralph Curcio.

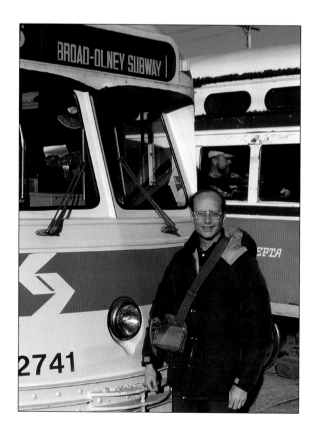

Ralph Curcio, many of whose photographs grace this book, poses for posterity on the final day of Route 6 trolley service, January 11, 1986. (Courtesy of Daniel McFadden.)

CONTENTS

ACKNOWLEDGMENTS

I never met Ralph Curcio, but his impact on this project was tremendous. Like me, he was a journalist and a railfan, with a passion for taking pictures. Ralph fought a difficult battle with cancer for nearly 20 years before passing away in 2012 at age 63. He was an extremely talented photographer, and the tens of thousands of train and trolley slides Ralph took were left in the care of his friend Daniel McFadden, who graciously scanned many of Ralph's Southeastern Pennsylvania Transportation Authority (SEPTA) images for me, along with some of his own. Ed Lybarger, archivist at the Pennsylvania Trolley Museum, granted permission to use many of Ralph's images that are now in the museum's collection. I owe much to Harry Donahue, a Friends of Philadelphia Trolleys founding member, who provided photographs and factual information—and introduced me to Daniel McFadden. I owe a great intellectual debt to Mike Szilagyi, whose respected and well-researched website, www.phillytrolley.org, has long been a valuable repository of photographs and historical information. At SEPTA, Andrew Busch and Manny Smith in media relations patiently assisted with my requests for background information. Dave Biles of the Electric City Trolley Museum Association granted access to photographs and documents in its collection, including vintage SEPTA reports. Adam Mohney at Brookville Equipment Corporation helped track down old photographs there. Many aided through the contribution of photographs; their submissions are acknowledged after captions as follows: Harry Donahue (HAD); Mike Szilagyi (MS); Rob Hutchinson (RH); Joel Salomon (JS); Daniel McFadden (DM); Rich Short (RS); Glenn L. Rowe (GLR); Brookville Equipment Corporation (BEC); Bill Monaghan (BM); Thomas Hawk (TH); Jean-Michel Delaporte (JMD); Matthew D. Cosgro (MDC); Bob Hasselbach via Harry Donahue (BH); Electric City Trolley Museum Association (ECTMA); and Ralph Curcio via Daniel McFadden (RCDM); Ralph Curcio photograph in Miller Library, Pennsylvania Trolley Museum (RCPTM); and the Pennsylvania Trolley Museum (PTM). Photographs by the author are labeled (RD). Friends Matt and Gail Kemeny graciously opened their home to me, where I did much of the writing. Fellow journalist James O'Malley—not a railfan—was patient company during some of my West Philly photography adventures. *Merci à tous.*

INTRODUCTION

Long after most North American cities consigned their trolleys to the scrap heap, streetcars still serve Philadelphia commuters on the largest surviving system of its kind in the United States. That system is only a fraction of the vast network that once existed, but still forms a significant component of the region's public transit infrastructure.

This book illustrates the history of Philadelphia's trolley cars under Southeastern Pennsylvania Transportation Authority (SEPTA) ownership since 1968, when that public sector entity purchased the privately owned Philadelphia Transportation Company. Because SEPTA is the key focus of this book, and because its acronym—pronounced, never spelled out— is a household word in the Philadelphia region, it will be referred to that way throughout the text.

There's another acronym readers will see consistently throughout: PCC. It refers to the Electric Railway Presidents' Conference Committee, an industry group that banded together to create an ultramodern trolley as automobiles had begun biting into transit companies' profits in the late 1920s. PCC cars have been a part of the Philadelphia transit scene since 1938, and their fortunes are another key theme in this book. Some basic roster information is contained at the end of chapter 1, but the main thing to know about PCC cars is that they came in two basic types. First came "air cars," in which the brakes, doors and windshield wipers were pneumatically powered. Then came the post–World War II "all-electric" cars, which dispensed with air-controlled functions in favor of electricity. The body styling also differed between the two types, as the photographs illustrate.

This book is about transportation technology, but it is also about how that technology evolved with the city it serves. This is not a definitive history, but hopefully it offers a vivid survey of how Philadelphia and its trolleys have changed over nearly half a century. A basic table listing the routes that existed during the period can be found at the end of chapter 1.

While the city lines are our primary focus, one chapter is devoted to suburban trolley lines serving Media and Sharon Hill, which SEPTA acquired in 1970 under its takeover of the Philadelphia Suburban Transportation Company's Red Arrow rail and bus network. The only notable omission here is SEPTA's Norristown High Speed Line. Though some locals still call the Norristown cars trolleys, hearkening back to that line's early-20th-century roots, the fully grade-separated, third-rail-powered rapid-transit route is a very different animal than SEPTA's city and suburban trolley car operations, which make substantial use of public streets, run at lower speeds, and take their power from overhead wires.

Understanding the SEPTA era also requires a basic understanding of how Philadelphia's fortunes have been closely intertwined with that of its transit systems. That complex relationship began before the Civil War, as transportation routes opened up new neighborhoods to commercial, industrial, and residential development.

A web of iron rails spread across the city in the late 19th century under multiple private companies, starting with horse-drawn cars in 1858. Electric trolleys followed in 1892, taking their

name from the way the streetcars' power poles "trolled" along the overhead wires. By the early 1910s, the Philadelphia Rapid Transit Company (PRT) had a near monopoly on city transit, with 3,999 cars operating on 86 routes and 678 miles of track—including a subway and trolley tunnel under Market Street, which first opened to West Philadelphia streetcars on December 15, 1905.

Even in the Depression years of the 1930s, when PRT fell into an eight-year receivership, the trolley system suffered only a few cutbacks—notably the replacement of some rural Delaware County lines with buses. In 1938, one of the most significant purchases in Philadelphia transit history brought the first 20 streamlined and efficient PCC trolleys to the city, first serving Route 53 along Wayne Avenue.

On January 1, 1940, PRT emerged from receivership as the Philadelphia Transportation Company, and officials quickly sought financing for new equipment. Motor buses and electric trolley buses powered via overhead wires (called "trackless trolleys" in Philadelphia) had become a presence locally in the 1920s—and the company was committed to buying more of them—but rubber-tired technology had yet to overtake trolleys as the dominant form of public transit on Philadelphia streets. In April 1940, the company announced orders for hundreds of new vehicles, including 130 more of the Art Deco PCC cars.

The company's march toward modernization was a race against time. Europe and Asia already were aflame with war, and America's entry into the conflict the following year would result in a tremendous industrial boom for the region, whose industries had been in a gradual decline since the 1920s. This was good for Philadelphia Transportation Company (PTC), and especially for its rail lines, which served key manufacturing areas. Ridership rose, but many old vehicles had to be refurbished when the production of new buses and trolleys all but ceased as factories nationwide changed gears to feed the war effort.

Trolleys still formed the backbone of the surface transit network at war's end. In 1946, the Philadelphia Transportation Company's fleet included 1,900 trolley cars, which served 58 routes and 560 miles of track and carried more than 600 million riders. The company even bought 210 new PCC cars in 1947–1948, bringing the number of streamliners up to 470. But that purchase came at a time when most US trolley systems had either been converted to buses or were working toward that goal, as Americans' love affair with the automobile resumed with a vengeance after the war. National trends quickly caught up with Philadelphia; like many American cities, it began hemorrhaging industrial jobs and people. Suburbanization and the victory of the car culture were one factor, but the growth of mass production hit older industries hard, and manufacturing companies folded or shifted production elsewhere.

The company lost nearly half its transit ridership between 1946 and 1954. With management pressed to cut costs, the aging trolley network was in its crosshairs. Even with all those new PCC cars, the fleet was still largely made up of loud, heavy, power-hogging trolleys, some dating back to 1911. Such sturdy, no-nonsense trolleys with wooden seats and bare lightbulbs were durable, but struggled to compete with the comfort of new buses and the convenience of private autos. The expense of maintaining trolley tracks and electric wires in public streets only exacerbated matters as revenues dwindled.

In 1952, the Philadelphia Transportation Company drafted a plan to eliminate all but 14 trolley routes within a decade, largely replacing them with trackless trolleys or gas buses. The watershed moment came in 1955, when new management under National City Lines—a transit conglomerate tied to bus builder General Motors and other automotive interests—adopted an even more aggressive approach. They decided to eliminate all but a handful of "subway-surface" trolley routes, which used the newly expanded Market Street subway (the city finally extended the tunnel under the Schuylkill River) to provide a speedy ride between West Philadelphia and Center City. For the trolley lines facing the axe, diesel-powered General Motors buses were the primary replacement, with more than 1,000 of them ordered for Philadelphia, although some secondhand PCC cars were acquired from other cities around this time to bolster the remaining fleet.

Most of the revised conversion goal was achieved by 1958, when only 14 trolley lines remained —as originally planned in 1952—but then the process stopped. With ridership still falling, finding the

capital for large bus purchases would have posed a financial challenge, and the company now had to contend with city officials' growing opposition to its anti-trolley policy.

In 1960, Philadelphia mayor Richardson Dilworth unsuccessfully suggested the city issue $75 million worth of bonds to buy the transit company. Dilworth's idea was not only slightly premature, but also too narrow in focus. Government-subsidized regional transit authorities, crossing municipal and county boundaries, were the new paradigm. In a way that private transit companies would not or could not do, these authorities were structured to acknowledge that jobs and housing were no longer confined to old central cities, but sprawled into suburbs and surrounding rural areas.

In August 1963, Pennsylvania governor William W. Scranton signed legislation establishing SEPTA, which came into being early in 1964. Its purview was to coordinate subsidies flowing to commuter rail and local transit operations across multiple counties, but takeover of the Philadelphia Transportation Company was one of SEPTA's key goals. While battles over the purchase price dragged on, to PTC's detriment—a shareholder proxy fight in 1966 helped derail a $59.8 million offer from SEPTA—the company spent as little as possible on maintenance and capital needs. On September 30, 1968, when SEPTA consummated its $47.9 million takeover, it inherited 14 city trolley lines and 465 cars, ranging from 20 to 28 years of age; of these, only about 400 were still operable, with both cars and infrastructure bearing visible scars from years of minimal maintenance. SEPTA faced tough choices about what to do with Philadelphia's aging trolleys; no new streetcars had been built in North America since 1952, as nationwide demand for the vehicles had all but evaporated. Efforts to build new cars for the surviving systems, such as Philadelphia, would not gather steam until the 1970s energy crisis a few years later.

There were some subtractions and additions in those early years. Route 47, which had been partially converted to buses due to downtown construction on the Port Authority Transit Corporation rapid transit line to New Jersey, was permanently changed to a bus route in 1969. In 1971, shuttle Route 62 between Yeadon and Darby was merged into Route 13. In 1970, on the other hand, the authority expanded its holdings with the acquisition of Philadelphia Suburban's Red Arrow lines, as noted above.

SEPTA launched efforts to spruce up some of its trolleys, especially the battered city division cars. Several new paint schemes were tried, as well as a rebuilding program commencing in 1973. But that work was relatively superficial. As the decade wore on, SEPTA's trolley fleet (as well as its diesel bus fleet) was plagued by breakdowns and accidents as officials struggled to maintain a state of good repair amid declining ridership and insufficient funding.

In 1976, preparations for celebrations marking the bicentennial of US independence brought some bright spots. For SEPTA, it meant the painting of vehicles in commemorative red, white, and blue designs (forerunners of the color scheme still used today), as well as the special appearance of an open-air boat-shaped trolley on loan from Blackpool, England. But tragedy ensured the boat car was not the first international trolley to grace Philadelphia rails. In October 1975, SEPTA's Woodland Depot caught fire, reducing 60 cars to a mass of charred and twisted metal. This created serious equipment shortages for SEPTA, which hurriedly purchased 30 thirdhand PCC trolleys from Toronto, Ontario. Originally built in 1946 for Kansas City, Missouri, and Birmingham, Alabama, the well-worn vehicles were pressed into service still in the Canadian city's red and cream colors.

By this time, SEPTA and most of the other remaining North American trolley operators realized that a source of new vehicles was desperately needed. SEPTA backed away from joining Boston and San Francisco in purchasing a new American design developed in conjunction with aircraft manufacturer Boeing. Rather, SEPTA worked with Kawasaki Heavy Industries of Japan to develop new vehicles closely tailored to the system's needs. The successful result of that collaboration was the construction of 141 "light-rail vehicles," to use the new nomenclature: 112 single-ended cars for the busy subway-surface lines (routes 10, 11, 13, 34, and 36) and 29 larger, double-ended versions for the ex-Red Arrow routes to Media and Sharon Hill (routes 101 and 102). Delivered between 1980 and 1982, the Kawasaki cars remain in daily service in 2016, while the trouble-plagued Boeing cars in Boston and San Francisco have been withdrawn.

SEPTA's trolley issues were not over, however. The remaining non-subway lines—the ones National City Lines failed to kill back in the 1950s—also needed better equipment if they were to continue as rail routes for any length of time. Using federal funding, SEPTA embarked in 1979 on an intensive overhaul program designed to give 50 of the postwar PCC cars an added eight to ten years of useful life. Unlike the earlier 1970s overhaul program, this effort turned out much better vehicles. It was, however, very slow. Expanded to include 112 cars, the project lasted until 1986, by which time some of the rebuilt red, white, and blue cars would have a very short service life in Philadelphia.

In 1982, a SEPTA report looked at the future of the routes on which the rehabilitated cars ran. While they extended to parts of South Philadelphia, the core of those lines were north of Market Street, including neighborhoods that had been hard-hit by business closures and population losses. The report argued that a pattern of deferred investment begun in the Philadelphia Transportation Company years meant substantial replacement of infrastructure was required in addition to new cars and concluded that the loss of ridership did not justify such an investment. The demise of those lines would not come immediately—and not without opposition from political and community leaders—but it was coming.

Route 60, along Allegheny Avenue, had been replaced with buses in 1977. North-south running Route 50 had stopped running in 1980, but SEPTA only officially declared it a bus line in 1985. Also that year, Wayne Avenue Route 53 was declared "temporary bus," with the electric wires taken down in 1989. In January 1986, SEPTA bucked the city's wishes by converting Route 6, along Ogontz Avenue, to buses.

Outside the subway-surface routes, that left only routes 15, 23, and 56, a crosstown route along Girard Avenue, the long north-south route from Germantown to South Philadelphia, and the much diminished Erie-Torresdale line. In 1992, SEPTA reached a deal with the city to temporarily replace the three trolley routes with buses, so long as SEPTA agreed to purchase new light-rail vehicles for them by 1997. When that did not happen, SEPTA found itself at odds with the city, including Mayor (later governor) Ed Rendell, who pushed hard for the restoration of trolleys, on Route 15 in particular.

In a September 1997 compromise, SEPTA agreed to buy 12 long articulated cars for the West Philadelphia lines, freeing up 18 Kawasaki cars to be refurbished for Girard Avenue. Sticker shock over the price of all-new vehicles led to another compromise: 18 of the 1947–1948 PCC cars rebuilt in the 1980s would be rebuilt again. The work was contracted out to Brookville Equipment Corporation in western Pennsylvania. The result was refurbished 1940s body shells covering entirely new control and propulsion systems, featuring air-conditioned interiors with wheelchair lifts. In a nod to heritage, the resulting vehicles, dubbed PCC-II cars, were painted in the Philadelphia Transportation Company colors they first wore back in 1947. The new Girard Avenue line debuted in September 2005.

Today, SEPTA is gearing up for the next generation of Philadelphia trolleys. While they are tentatively listed in budget documents as a 2022–2028 project, officials say formal timelines for vehicle purchase and related infrastructure upgrades are yet to be determined. SEPTA has had discussions with manufacturers, however, and in 2016 said it envisions 80-foot articulated, low-floor cars as the new standard to accommodate growing ridership. As was done 35 years ago, SEPTA says it would look to replace the city and suburban fleets in one purchase, with some old and new trolleys operating together until all new vehicles are phased in. SEPTA also says it will look at possible uses for the PCC-II cars after the new cars arrive. Amid these developing plans, the future of returning trolleys to routes 23 and 56 remains unclear, however.

The final chapter looks at what happened to some old Philadelphia trolleys. Many found their way to museums across the country. On a similar note, an enthusiasts' group known as Friends of Philadelphia Trolleys formed to help raise money for restoring Philadelphia cars owned by different museums. Other cars were reborn as active transit vehicles, most notably in San Francisco. Thus have the streetcars of Philadelphia proven themselves true survivors.

One

STILL ROLLING

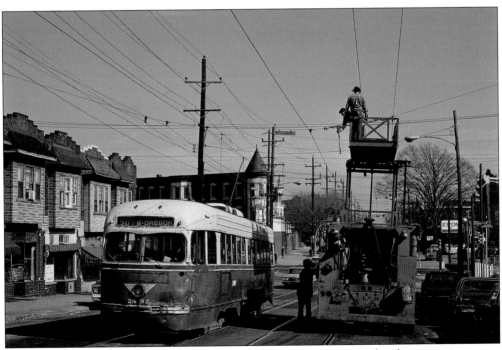

Thirty-four years of service hang heavily on car 2592 as it passes an overhead wire repair crew on Wyoming Avenue in 1976. (RCPTM.).

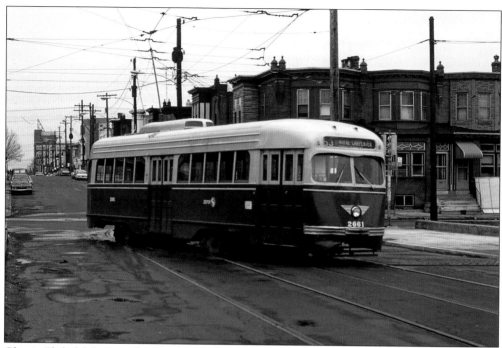

Classic Philadelphia row houses form a backdrop to this 1972 photograph of car 2661 at 10th and Luzerne Streets. (DM.)

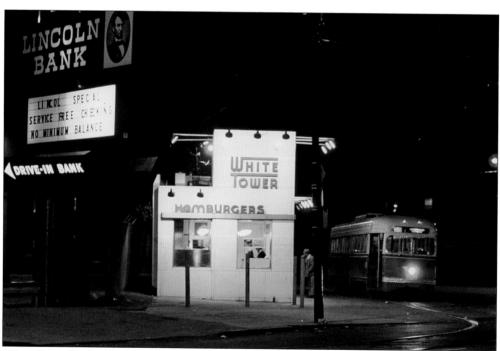

White Tower burgers beckon as a Route 56 car awaits departure from 23rd and Venango Streets in 1975. (RCPTM.)

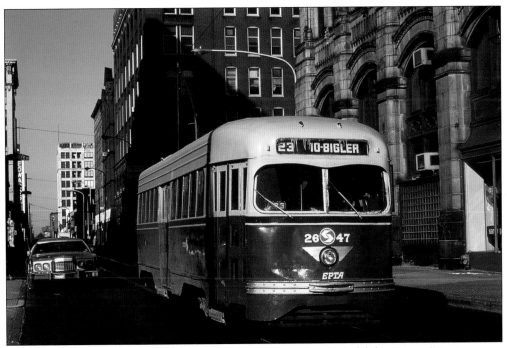

Car 2647, working on Route 23 in 1976, was the second to last Philadelphia "air car" in existence. Badly deteriorated, it was scrapped at the Baltimore Streetcar Museum in 2013 to provide spare parts for another restoration project. (RCPTM.)

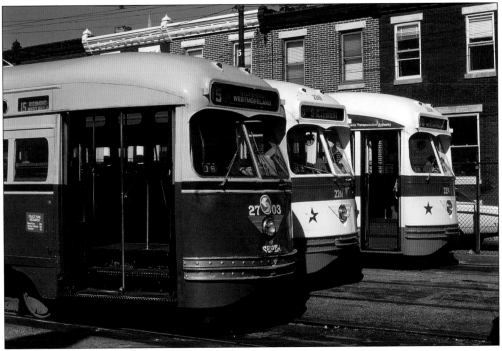

The old Philadelphia Transportation Company colors on 2703 contrast with two cars in commemorative Bicentennial paint at Richmond and Westmoreland Loop in 1976. (RCPTM.)

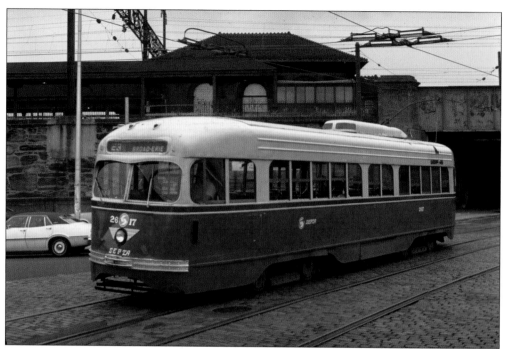

Car 2617 travels southbound on Germantown Avenue at Windrim Avenue in 1977, underneath the spot where the twin wires for trackless trolley Route 75 cross overhead. (MS.)

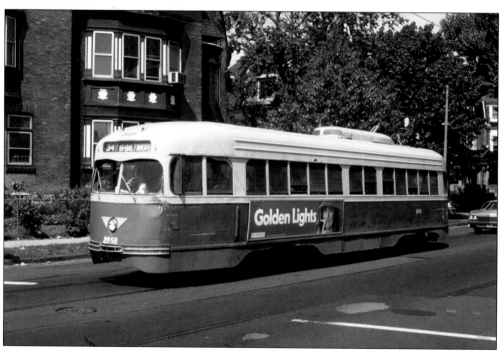

Tobacco advertisements were still common when 2658 was photographed on Baltimore Avenue near 48th Street in the late 1970s. (MS.)

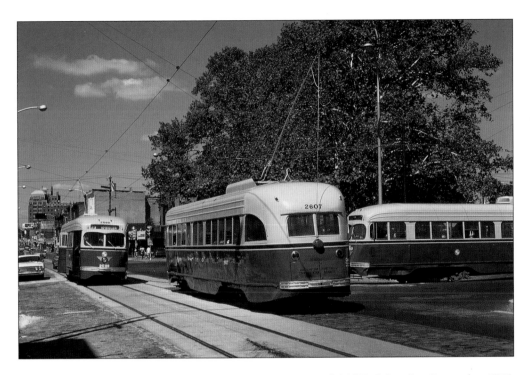

Three green air cars congregate at Germantown Avenue and Old York Road in September 1976. A similar photograph in another book suggests railfan Ralph Curcio may have been traveling with a friend that day. Below, Curcio captured a close-up of car 2069 before it pulled away. (Both, RCDM.)

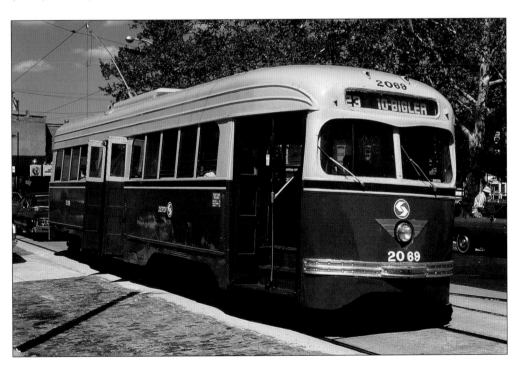

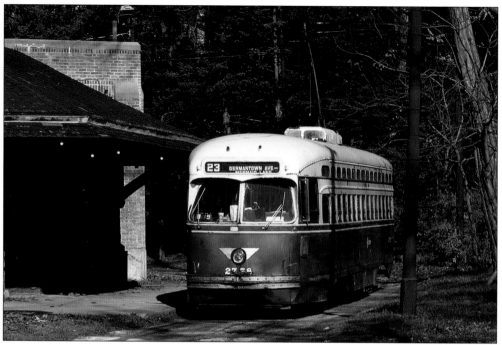

Rusty "all-electric" car 2758 waits for passengers at Route 23's rustic-looking Mermaid Loop in 1977. Later rebuilt as 2331, it still operates today on the Girard Avenue line. (RCPTM.)

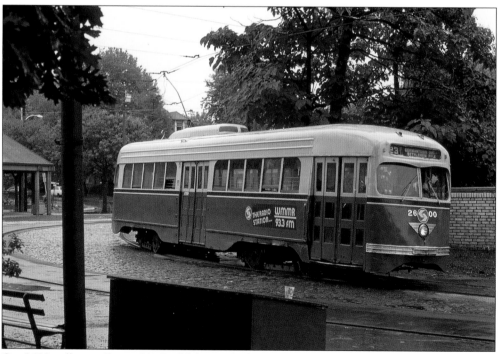

Car 2600 pulls into Route 23's Bethlehem Pike loop on a rainy August day in 1977. The quaint cobblestone neighborhoods served by the route's northern half were a stark contrast to the narrow streets of South Philadelphia that cars clattered through on the other end. (RCDM.)

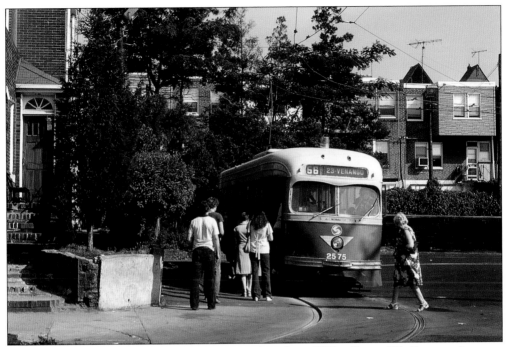

Passengers in summer outfits wait their turns to board car 2575 at Route 56's Cottman Loop on a sunny day in July 1980. (RCPTM.)

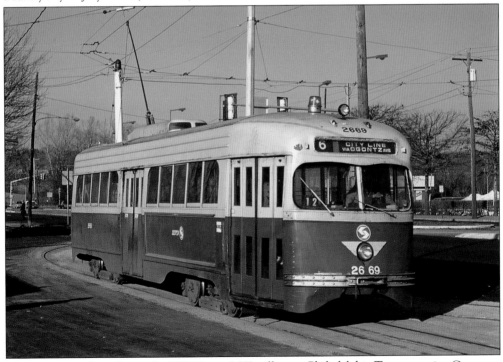

Thirteen years after takeover by SEPTA, car 2669 still wears Philadelphia Transportation Company colors at Cheltenham and Ogontz Loop in December 1981. Some cars were never repainted in their new owner's livery. (RCDM.)

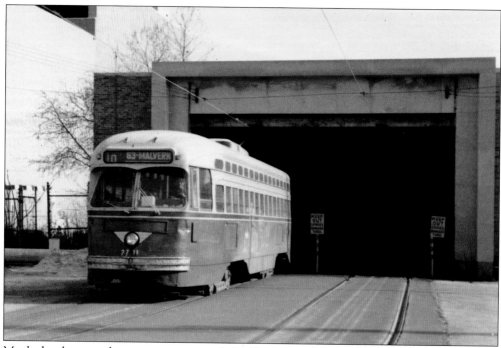

Much development has sprung up around the Route 10 subway portal near 36th and Market Streets since car 2711 emerged from the tunnel on a westbound trip on what looks like a chilly morning in the 1970s. This car appears in its preserved state on page 92. (ECTMA.)

Rush-hour passengers can be seen inside a Route 11 car and waiting for other routes at the 13th Street subway-surface station in this 1970s view. (ECTMA.)

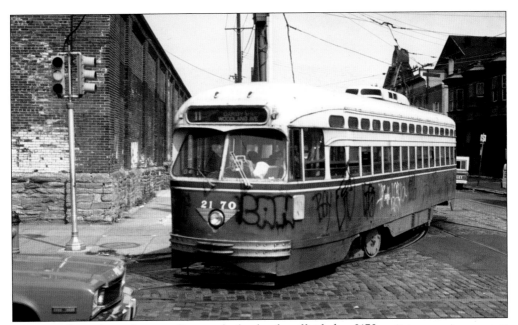

One can almost hear the squealing steel wheels of graffiti-laden 2170 as it turns a corner near Woodland Depot in the late 1970s. SEPTA's current fleet of white cars has been maintained in nearly immaculate condition over more than 35 years, but such vandalism also has waned citywide. (MS.)

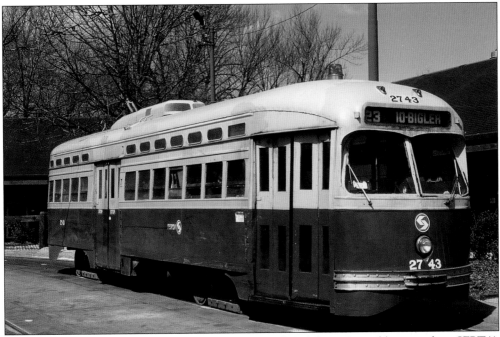

March 1983 found 36-year-old car 2743 stained, dented, and dusty. It would emerge from SEPTA's overhaul program the following year in much better shape. For its present guise, see chapter 5. (RCDM.)

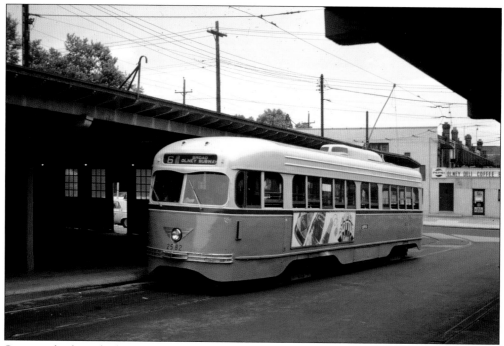

Stepping backward a bit, SEPTA had begun experimenting with new color schemes as early as 1969, when 2582 could be found at the Olney Terminal of Route 6. This tan livery never became standard, however. (RH.)

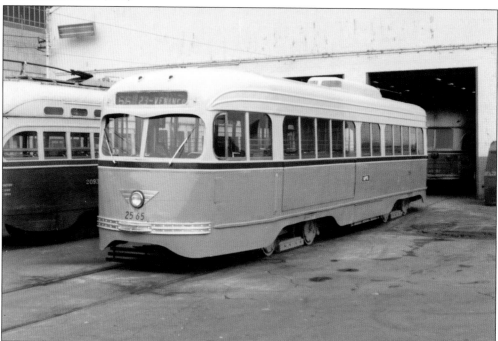

Air car 2565 also wore the tan livery for a time, complete with SEPTA's early rectangular logo, before the now-familiar stylized "S" design appeared. The car is seen at Courtland Shops in 1969. It would be the first painted orange in 1973. (HAD.)

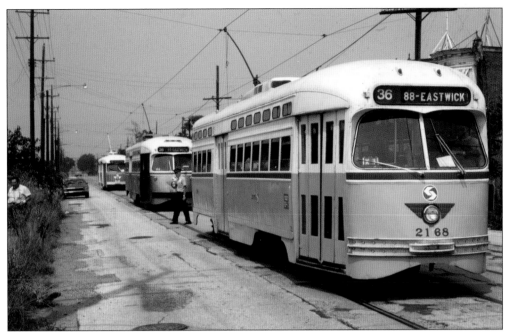

Three of SEPTA's experimental paint schemes are seen in this 1970s fan trip at the former outer end of Route 36. First is 2168 in yellow, followed by a gold car. Last comes an orange, white, and blue trolley. Popularly dubbed "Gulf Oil" after the famous petroleum company's logo, the orange scheme would be the only one widely used, albeit only for a short time in the 1970s. (JS.)

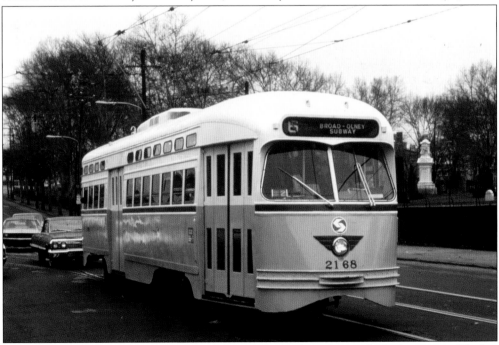

Here is 2168 again in yellow in the 1970s. It was derisively nicknamed "the banana car" before being repainted in Gulf Oil colors. This car survives at the Baltimore Streetcar Museum in Maryland, as seen in chapter 5. (JS.)

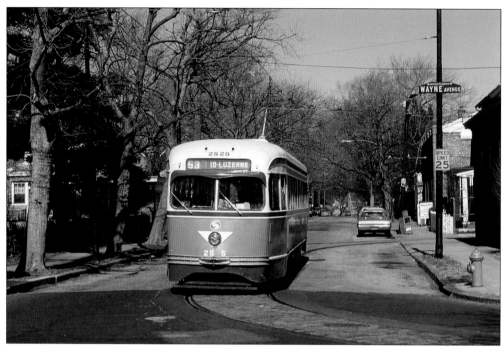

SEPTA debuted the Gulf Oil colors in 1973, with 2565 (seen in the following image) the first specimen. Here, sister car 2525 wears the livery at the outer end of Route 53 in 1976. (RCPTM.)

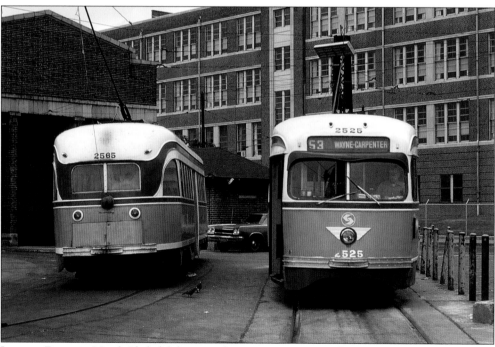

Luzerne Depot in North Philadelphia was the eastern terminus of Route 53. There, in 1976, car 2525 and sister 2565 (seen in tan on page 20) are now clad in what was becoming SEPTA's standard livery, even though some cars were surprisingly being repainted in green and cream. (DM.)

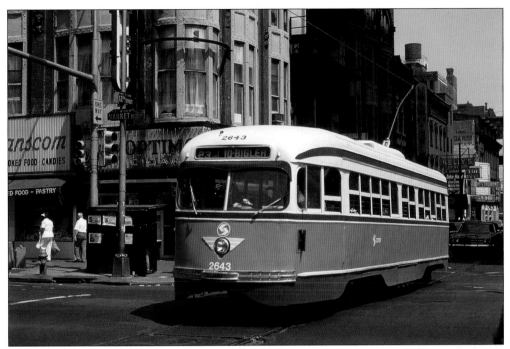

The new colors did bring a sharp new appearance to old trolleys, although they often masked more serious mechanical problems beneath the surface. Here, Route 23 car 2643 rolls south across Market Street in 1977. The 1942-vintage trolley still had about five years of service left. (RCPTM.)

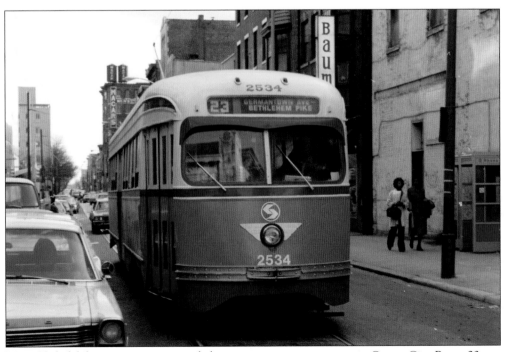

Many Philadelphia transit routes travel along separate one-way streets in Center City. Route 23 was split between 11th and 12th Streets. Car 2534 is seen northbound on 11th Street in 1977. (BH.)

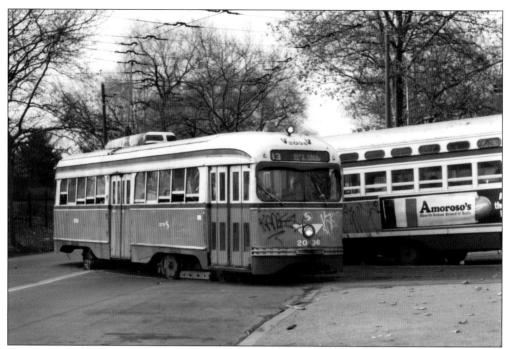

Graffiti reached near epidemic proportions in the 1970s, as evidenced by the condition of 2036 and another car at the 40th Street subway portal. Every part of the cars was fair game for taggers, including windows in some cases. (ECTMA.)

There is no graffiti visible on the street side of this car as it travels along Baltimore Avenue; however, its orange paint looks dusty and a bit faded. (ECTMA.)

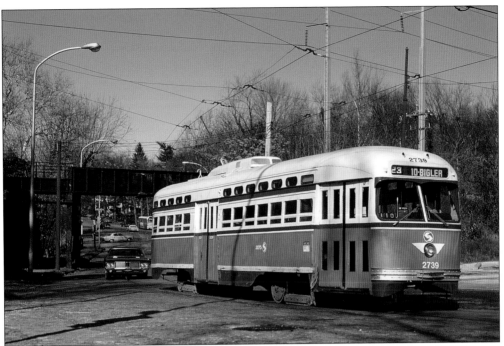

All the leaves are gone as car 2739 rolls along Germantown Avenue in November 1977. This car later found its way to a property in Brooklyn, New York. It was scrapped in 2008. (RCPTM.)

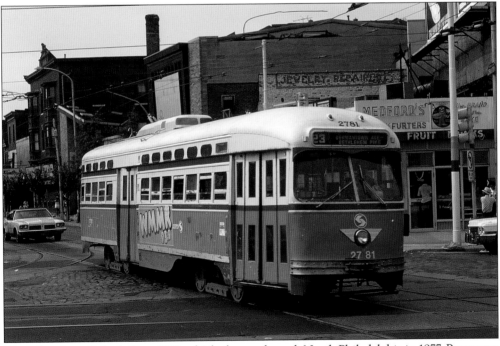

Paint chips have flaked off car 2781, which clatters through North Philadelphia in 1977. Passengers and the media were highly critical of the system in these years, as breakdowns and safety issues were constant concerns. (DM.)

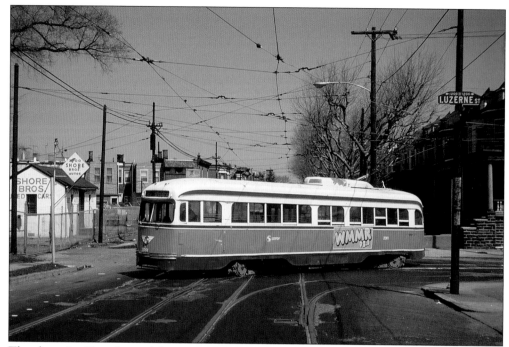

The clean Art Deco lines of the prewar PCC car design can be seen in this 1979 broadside view of 2061 at Old York Road and Luzerne Street. (RCPTM.)

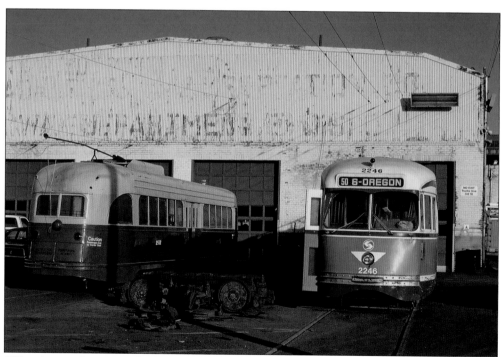

Old and new colors are on display in 1979 at Courtland Shops, where cars were painted—sometimes still in green, as previously noted. (RCDM.)

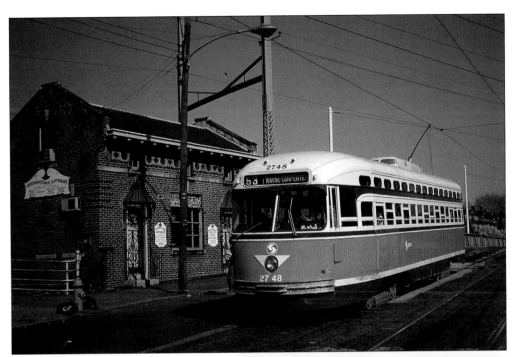

Car 2748 crosses a railroad overpass on Wayne Avenue in 1979. Route 53 was converted to "temporary bus" six years later, and the overhead wires were taken down a few years after that. Tracks still remain in some places, including this bridge. (RCPTM.)

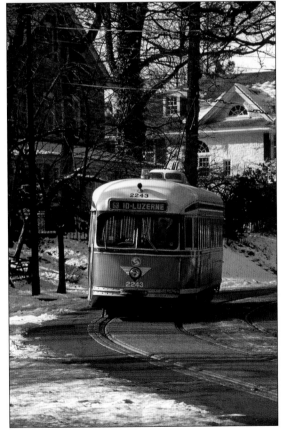

This area of Wayne Avenue, where 2243 is seen in December 1981, is characterized by large homes in a wooded setting. Its residents were among the first to be served by PCC cars when they were introduced to the city in 1938. (RCPTM.)

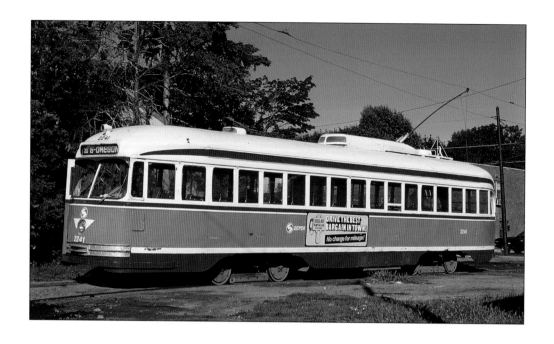

Originally built for Kansas City, car 2241 came to Philadelphia by way of Toronto in 1976. It is seen above awaiting its next run at Rising Sun and Knorr Loop in 1978. Below, the same car holds down a Route 56 service in 1980. (Both, RCDM.)

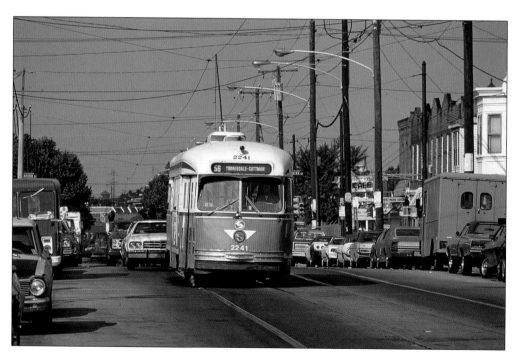

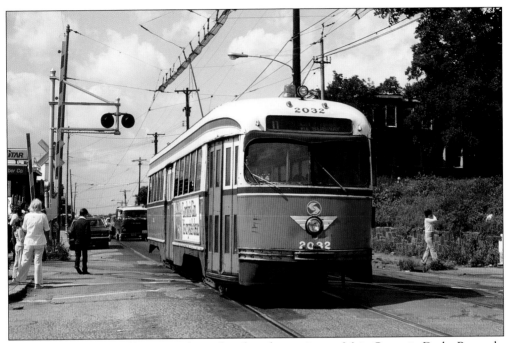

Route 11 trolley cars still traverse this railroad grade crossing on Main Street in Darby Borough, as air car 2032 does on a sunny September day in 1981. (RCPTM.)

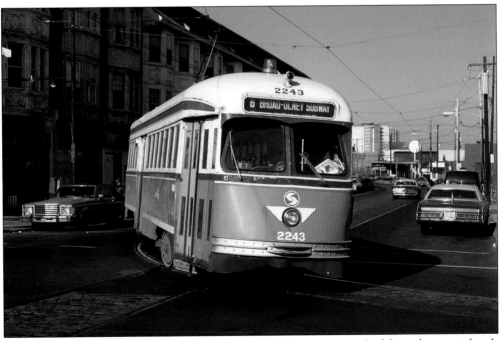

Another former Toronto, former Kansas City car, 2243 sports mismatched front doors as it heads toward Olney Terminal in December 1981. (RCPTM.)

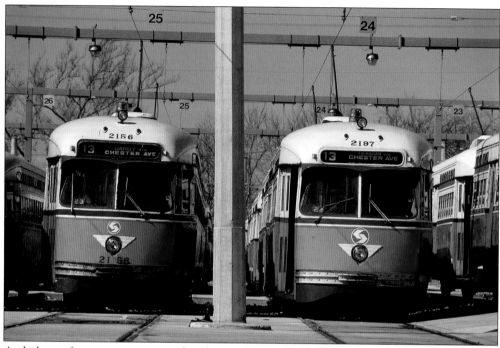

A phalanx of orange cars rests in the Elmwood Depot yard in 1982. Their days were numbered, as new Kawasaki-built light-rail trolleys were taking over duties on the busy West Philadelphia subway-surface routes. (RCDM.)

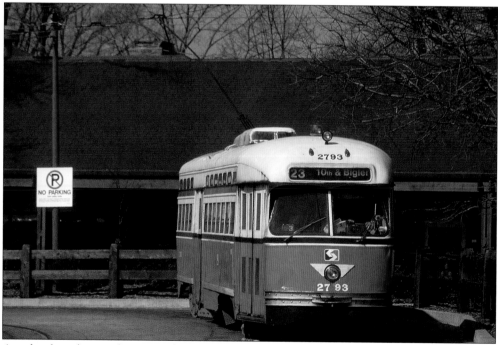

Another branding evolution can be seen on 2793, as it wears the 1970s colors in 1983, but with the newer rectangular SEPTA logo. (RCDM.)

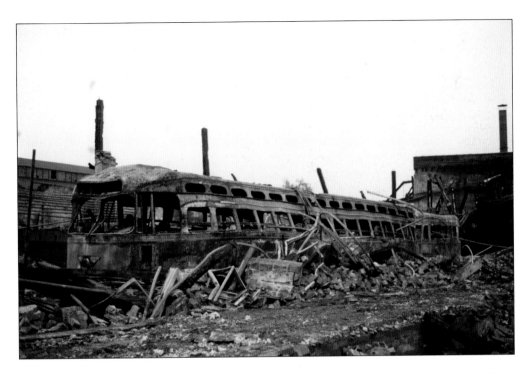

Tragedy struck SEPTA in October 1975, when flames tore through a large part of the Woodland Depot complex, destroying nearly 60 cars. It would result in the purchase soon after of used trolleys from Toronto, and helped push the agency toward purchasing new vehicles a few years later. (Both, RS.)

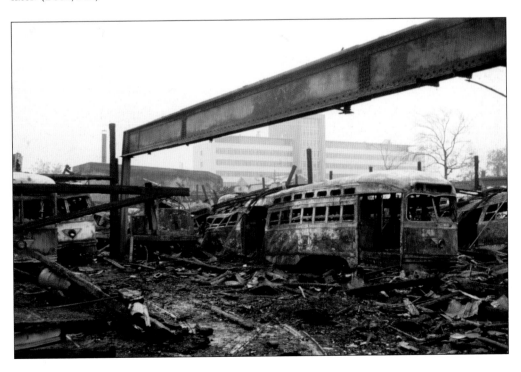

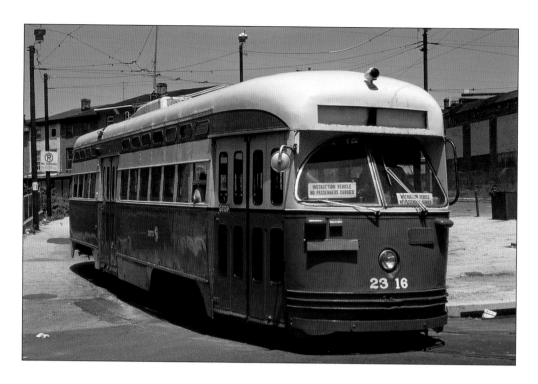

The Toronto cars were thirdhand, some from Kansas City (below) and others from Birmingham, Alabama (above). They were pressed into service in the Canadian city's colors, as seen in these May 1976 photographs, and many were never repainted. (Both, RCPTM.)

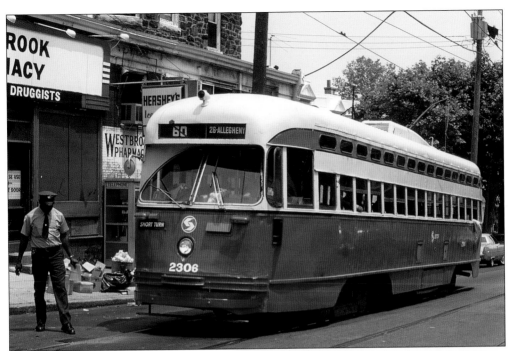

Appearances can be deceiving. This ex–Toronto/Birmingham car is not on Route 60, but on Lancaster Avenue during a fan trip. The car to the right, on Route 50, is on active duty, meanwhile. (Both, RCDM.)

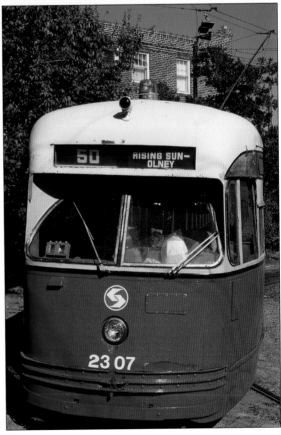

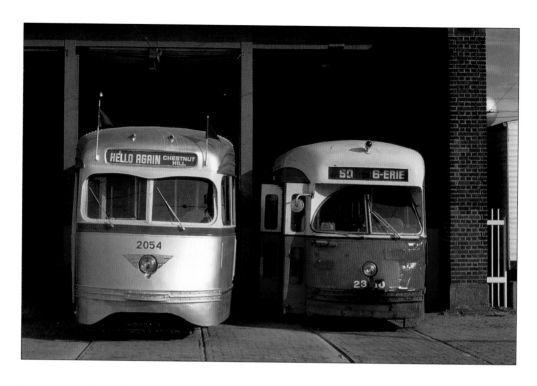

Battle-scarred 2310 from Toronto and Birmingham sits beside shiny 2054, a Philadelphia original that was repainted in the color scheme used on the city's first PCC cars in 1938. Below, 2310 is seen working a wavy stretch of track along Route 53 in 1979. (Both, RCDM.)

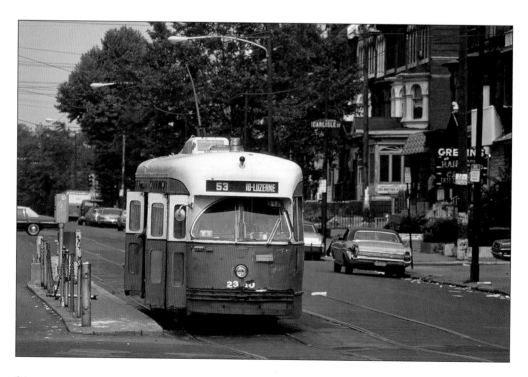

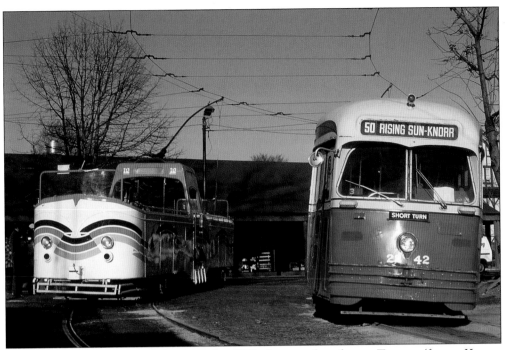

There are two international guests in this 1976 photograph: a former Toronto (former Kansas City) car at right and an open "boat" trolley on loan from Blackpool, England, to celebrate the bicentennial of American independence. (RCPTM.)

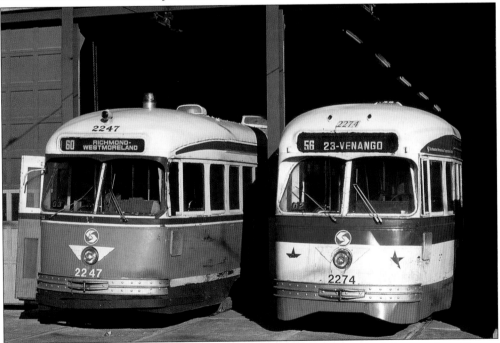

Here are two cars, two paint schemes, and two stories. The one on the left came from Kansas City by way of Toronto in 1976. The one on the right came directly from the Midwestern city in 1955. (RCPTM.)

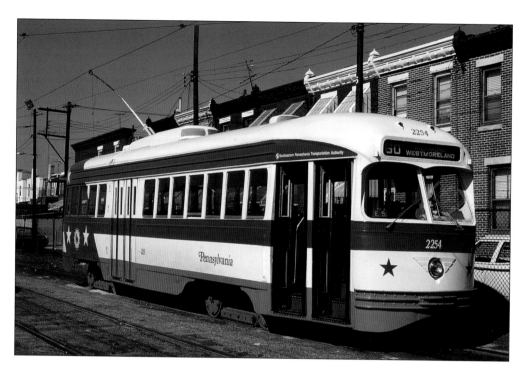

SEPTA painted 27 ex–Kansas City cars in red, white, and blue to honor the bicentennial, each bearing the name of an original colony. Car 2254, above, is one of three to honor Pennsylvania. Below, one of the commemorative cars gets a bath outside Luzerne Depot. Both photographs were taken in 1976. (Both, RCPTM.)

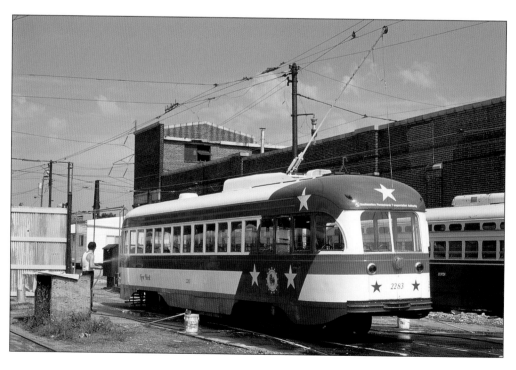

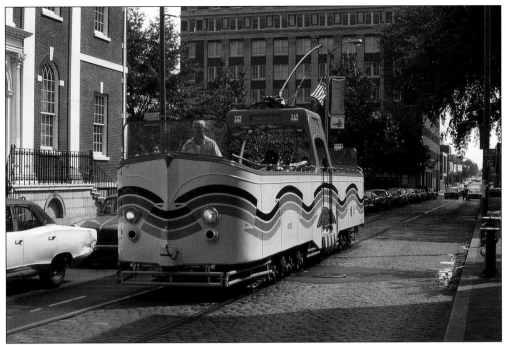

The Blackpool boat rolls through Center City on Route 50 in August 1976. It later returned to England before finding a permanent home in San Francisco. (RCPTM.)

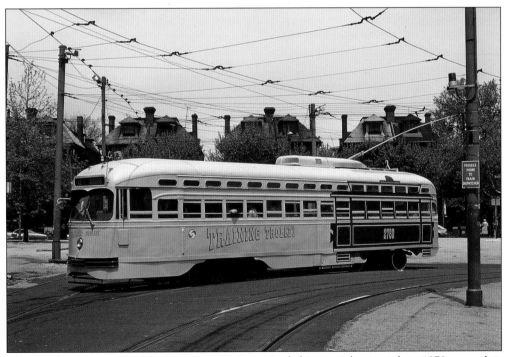

Unrelated to historical celebrations, car 2780 received this special paint job in 1979 to mark it out as SEPTA's training trolley for operators. It is seen at the 40th Street subway-surface portal in May of that year. (RCDM.)

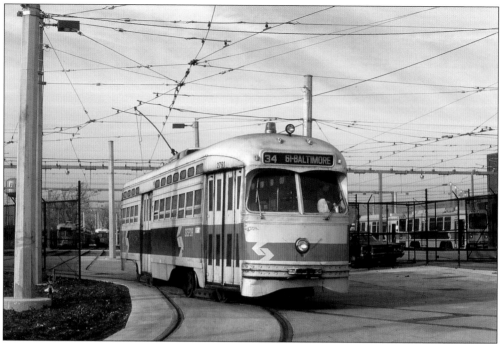

By the late 1970s, it looked like red, white, and blue would become SEPTA's new official colors. This car, 2791, received an early version of the scheme before later going through the formal overhaul process. (RCDM.)

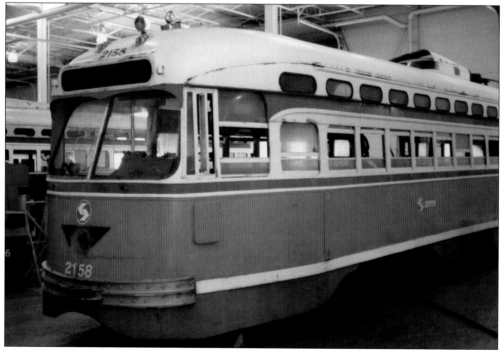

Inside Woodland Shops, crews will soon begin stripping faded and rusty car 2158 as part of the 1980s overhaul process. It would later be rebuilt again as 2335 for the Girard Avenue line. (HAD.)

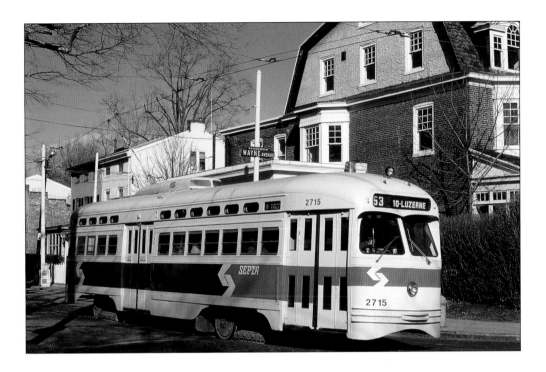

Pilot overhaul car 2715 (see page 2) is seen in its new guise on Wayne Avenue in 1981. Below, a pair of overhauled PCC cars have arrived at the Wayne-Carpenter Loop on a spring day three years later. (Both, RCDM.)

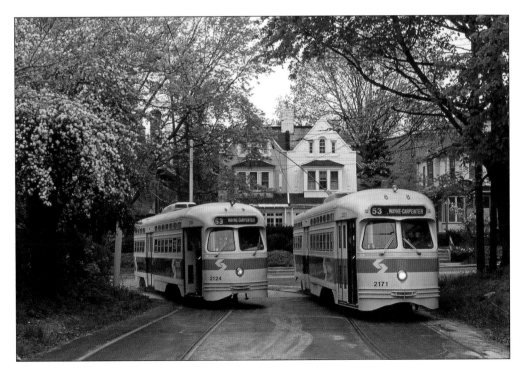

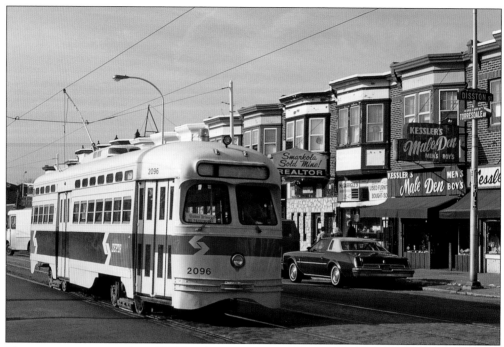

There are no passengers aboard 2096 as the car operates in driver-training service past neighborhood shops on Torresdale Avenue in December 1981. (RCPTM.)

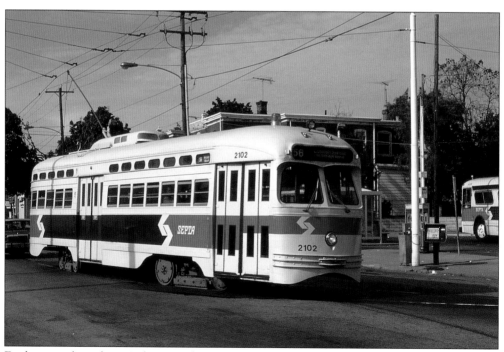

Farther east along the same line, another overhaul car is seen pulling into the Torresdale-Cottman Loop to meet a waiting bus in 1983. (DM.)

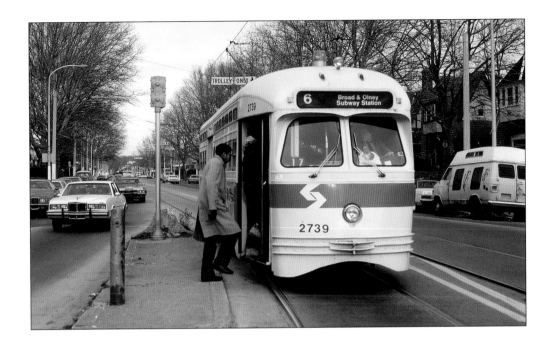

Conversion of Route 6 to buses was just over two weeks away when 2739 stopped for passengers in December 1985. The skies were clear and blue when the end came on January 11, 1986, making for memorable photographs such as this shot of 2788 at the Cheltenham-Ogontz Loop. (Both, DM.)

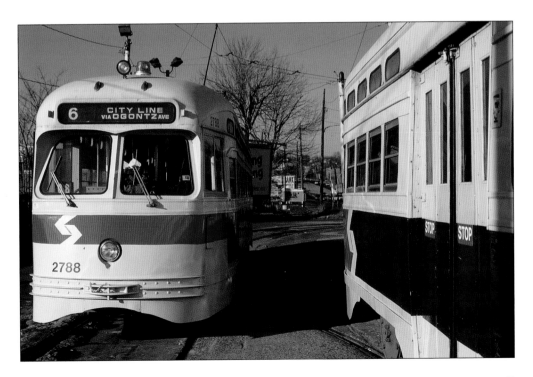

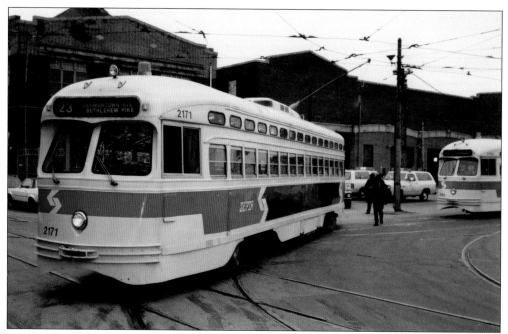

Luzerne Depot was a popular place for railfans looking to take pictures of North Philadelphia trolleys heading to and from their routes. Car 2171 and another rebuilt PCC are seen between assignments outside the facility in the late 1980s. (HAD.)

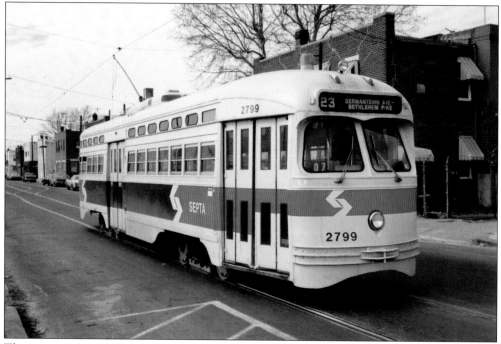

There was no loop at the southern end of Route 23, where cars like 2799 merely lay over in the middle of the street until it was time to head north again. (HAD.)

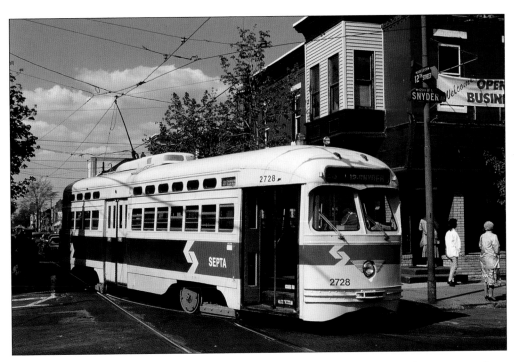

Because Route 23 was so long and so congested, there were many intermediate points where trolleys could turn back short of their final destination if necessary. One such place was Snyder Avenue in South Philadelphia, where 2728 turns off 12th Street in 1991. Below, the car lays over while a Route 79 trackless trolley passes by. Both routes are now operated with diesel buses. (Both, RCPTM.)

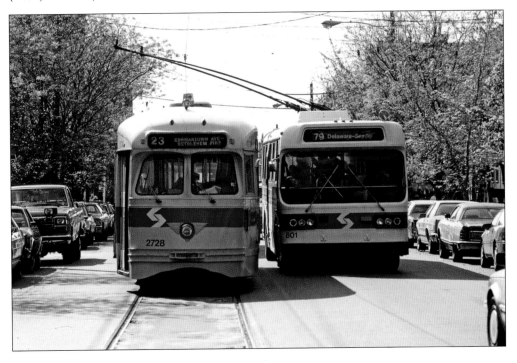

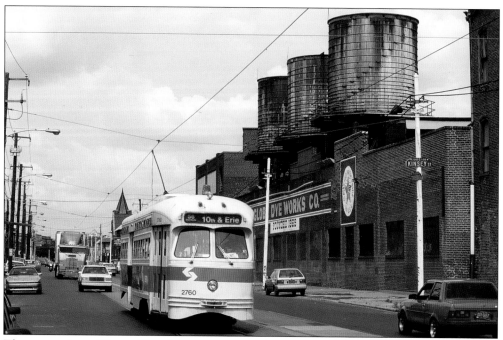

The conversion of Route 56 to buses was approaching as car 2760 passes this industrial plant on Torresdale Avenue in June 1992. The loss of many factories in the area is one reason transit ridership dropped dramatically. The Globe Dye Works closed in 2005, but its buildings survive and are being redeveloped. (RCPTM.)

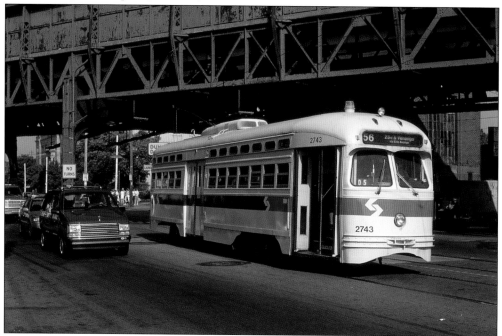

The last day of Route 56 trolley service has arrived, and car 2743 pauses to discharge riders under the Market-Frankford Elevated. Images of this car as it appears today can be seen on page 95. (RCPTM.)

PHILADELPHIA TROLLEY ROUTES IN THE SEPTA ERA

Subway-Surface	From	To	Status
10 LANCASTER Av - OVERBROOK	13th & MARKET	63rd & MALVERN	OPERATING
11 WOODLAND Av - DARBY	13th & MARKET	DARBY TRANSPORTATION CTR.	OPERATING
13 CHESTER Av - YEADON	13th & MARKET	YEADON / DARBY TRANS. CTR.	OPERATING
34 BALTIMORE Av - ANGORA	13th & MARKET	61st & BALTIMORE	OPERATING
36 ELMWOOD Av - EASTWICK	13th & MARKET	80th & EASTWICK	OPERATING

Surface	From	To	Status
6 OGONTZ AVENUE	BROAD & OLNEY	CHELTENHAM & OGONTZ	BUS SINCE '86
15 GIRARD AVENUE	RICHMOND & WESTMORELAND	63rd & GIRARD	OPERATING
23 GERMANTOWN Av / 11th-12th	10th & BIGLER	G'TOWN & BETHLEHEM PIKE	BUS SINCE '92
47 8th & 9th STREETS	WOLF STREET	5th & GODFREY	BUS SINCE '69
50 RISING SUN AVENUE / 4th-5th	6th & OREGON	RISING SUN & KNORR	BUS SINCE '89
53 WAYNE AVENUE	10th & LUZERNE	WAYNE & CARPENTER	BUS SINCE '85
56 ERIE & TORRESDALE Aves	23rd & VENANGO	TORRESDALE & COTTMAN	BUS SINCE '92
60 ALLEGHENY AVENUE	RICHMOND & WESTMORELAND	35th & ALLEGHENY	BUS SINCE '77
62 YEADON-DARBY SHUTTLE	YEADON LOOP	DARBY LOOP	MERGED w / RT. 13, '71

Suburban	From	To	Status
101 MEDIA	69th STREET	MEDIA	OPERATING
102 SHARON HILL	69th STREET	SHARON HILL	OPERATING

6 — Former Willow Grove suburban, cut back to Cheltenham & Ogontz, 1958. Last trolley 1/11/86.

15 — Made "temporary bus" in September 1992. Formally restored using PCC-II cars, 2005.

23 — "Temporary bus" along with 15 and 56 in '92. Bus route split into 23 and 45, November 2015.

47 — Southern half bussed due to PATCO construction in 1967. Last trolley 6/15/69.

50 — Last trolleys September 1980. Formal vote for permanent bus replacement, October 1985.

53 — Made "temporary bus" in 1985. Overhead wires removed in 1989.

56 — "Temporary bus" along with 15 and 56 in '92. Tracks paved over, wires partially removed.

60 — Last service September 1977.

This is a basic description of city and suburban trolley routes operated by SEPTA from 1968 to present. Terminal locations varied for some routes over the years, and intermediate turnback locations are not shown. (RD.)

SEPTA TROLLEY ROSTER

City PCC Cars*	Delivered	Builder	Control type	Status	Notes
2501-2580	1940	ST. LOUIS CAR Co.	AIR	LAST CAR 1982	1
2031-2080	1941	ST. LOUIS CAR Co.	AIR	LAST CAR 1982	2, 7
2081-2090	1942	ST. LOUIS CAR Co.	AIR	LAST CAR 1982	2
2581-2623	1942	ST. LOUIS CAR Co.	AIR	LAST CAR 1982	1
2624-2680	1942	ST. LOUIS CAR Co.	AIR	LAST CAR 1982	2
2701-2725	1947	ST. LOUIS CAR Co.	ELECTRIC	LAST CAR 1992	2
2726-2800	1947	ST. LOUIS CAR Co.	ELECTRIC	LAST CAR 1992	1, 3
2091-2140	1948	ST. LOUIS CAR Co.	ELECTRIC	LAST CAR 1992	2
2141-2200	1948	ST. LOUIS CAR Co.	ELECTRIC	LAST CAR 1992	1, 3
2251-2290	1955 (used)	ST. LOUIS CAR Co.	ELECTRIC	LAST CAR 1985	2, 4
2240-2250	1976 (used)	ST. LOUIS CAR Co.	ELECTRIC	LAST CAR 1983	2, 4, 5
2300-2318	1976 (used)	PULLMAN-STANDARD	ELECTRIC	LAST CAR 1982	2, 6

Light Rail Cars	Delivered	Builder	Type	Status	Notes
9000-9111	1980-1982	KAWASAKI HEAVY INDUSTRIES	SINGLE-END CITY CARS	IN SERVICE	8
100-128	1980-1982	KAWASAKI HEAVY INDUSTRIES	DOUBLE-END SUBURBAN CARS	IN SERVICE	8

PCC-II Cars	Delivered	Builder	Control type	Status	Notes
2320-2337	2003-2004	BROOKVILLE EQUIPMENT CORP.	ELECTRONIC MICROPROCESSOR	IN SERVICE	9

Notes

* Earlier classes retired before the SEPTA era not shown; total PCCs acquired by SEPTA from PTC was 465. Pre-SEPTA Red Arrow fleet also not shown.

1 - General Electric motors.

2 - Westinghouse motors.

3 - Some cars in limited/charter service before 2004.

4 - Built for Kansas City, Mo. in 1946.

5 - Acquired third-hand from Toronto, Ontario, Canada.

6 - Built for Birmingham, Ala., 1946; acquired from Toronto.

7 - 2054, preserved in Scranton, is only surviving air car.

8 - Trolley poles on city cars, pantographs on suburban cars.

9 - Rebuilt from various 1947-48 city PCC cars.

This is basic roster information for SEPTA's trolley fleet since 1968. Extensive car-by-car information can be found online at Mike Szilagyi's Phillytrolley.org website. (RD.)

Two

RED, WHITE, AND NEW

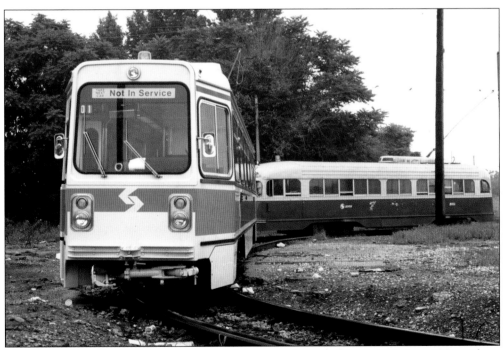

New Kawasaki trolley 9001 is seen on a training run at the end of Route 36 in June 1981, with an air car behind. While the green and cream PCC is but a memory, 9001 and its sisters remained in service in 2016. (MS.)

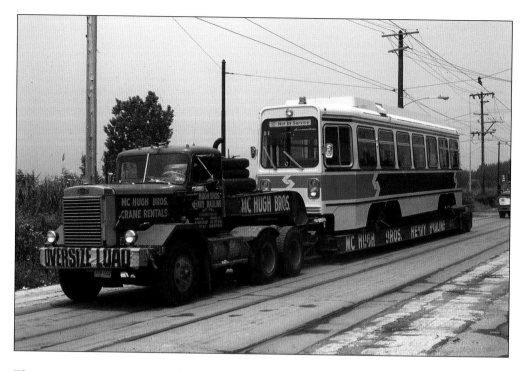

The outer end of Route 36 served as delivery point for the modern light-rail vehicles. Above, 9007 arrives at its destination aboard a flatbed truck. Below, Kawasaki employees ease 9006 down onto the rails. The bodies were built in Japan but finished at the Boeing Vertol plant in Ridley Park near Philadelphia to meet "Buy American" purchasing requirements. (Both, MS.)

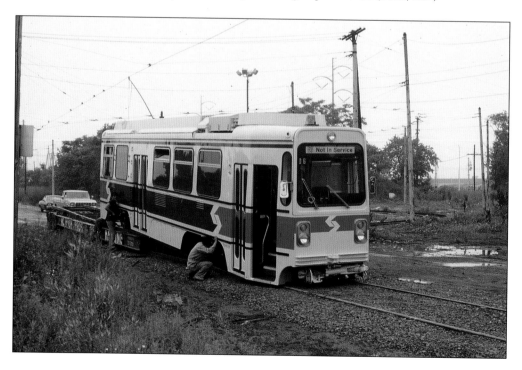

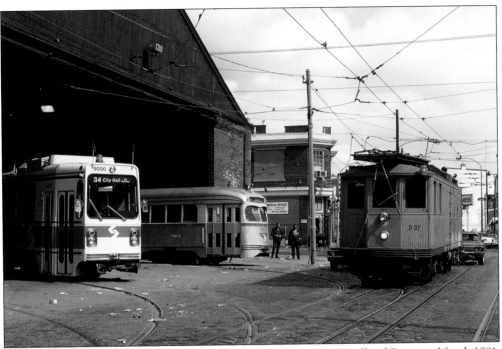

Kawasaki-built car 9000 is definitely the baby of this trio outside Woodland Depot in March 1981. Air car 2054 dates back to 1941, while work car D-37 is six decades old at the time. (RCDM.)

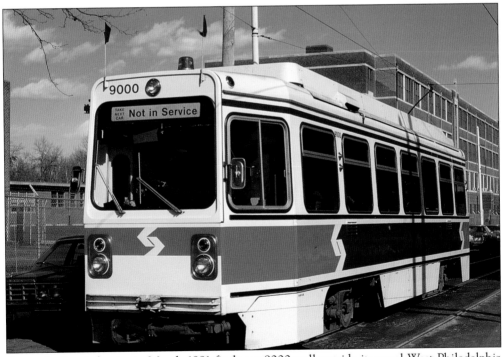

An enthusiasts' charter in March 1981 finds car 9000 well outside its usual West Philadelphia service area; instead, it is near Luzerne Depot in North Philadelphia. Its original paint scheme, with a wide blue and red band, can be seen clearly. (RCDM.)

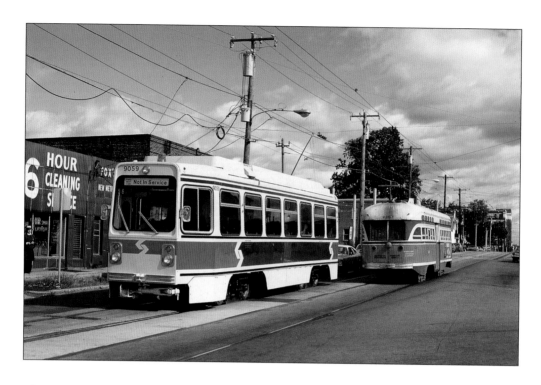

These images capture shiny new Kawasaki cars near their primary base at Elmwood Depot in 1981. Above, 9059 passes a worn PCC outside the depot, while the view below shows pedestrians waiting to cross as a pair of cars heads into and out of the then-new complex. (Both, RCPTM.)

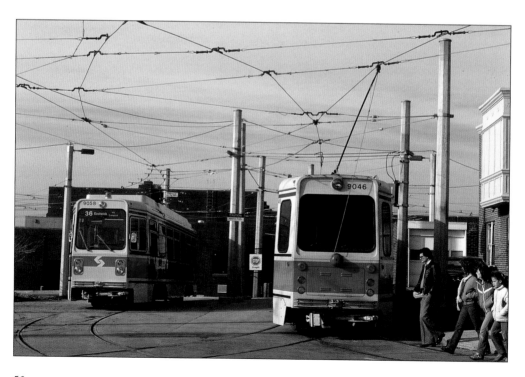

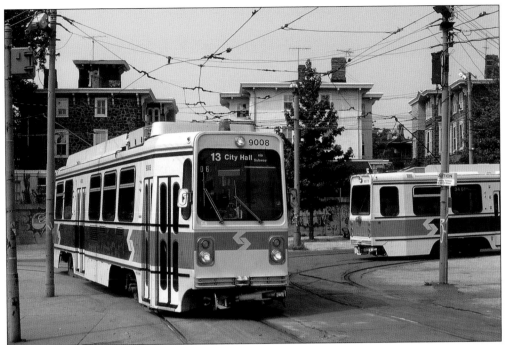

The 40th Street portal area is another favorite spot for trolley fans, with five lines converging on the tunnel mouth. New cars using routes 13 and 34 are seen at the junction in 1982. Modern shelters and new paving have been added, but the scene still looks much the same today. (RCPTM.)

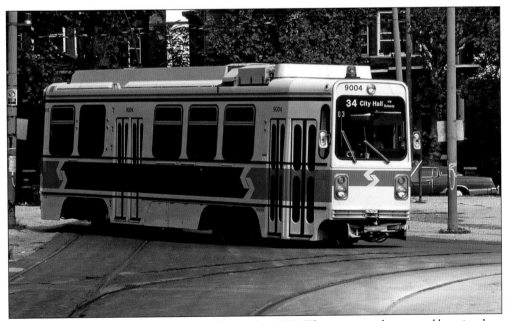

Car 9004 heads for the tunnel mouth in September 1982. These cars are longer and heavier than the PCC cars they replaced. Their increased power consumption has been balanced by durability and dependability. (DM)

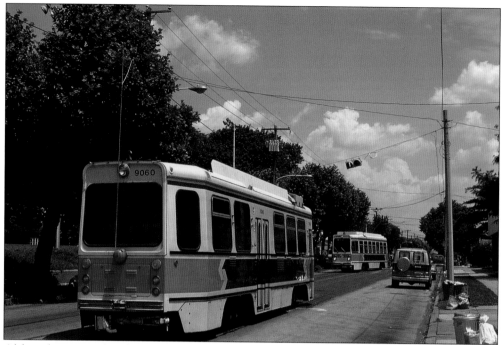

Although equipped with front and rear couplers, as visible on 9060, the Kawasaki cars have nearly always operated as single units and not in trains. Although the cars are boxy, their large picture windows and bright lighting won points with riders who found the old PCC cars more claustrophobic. (RCDM.)

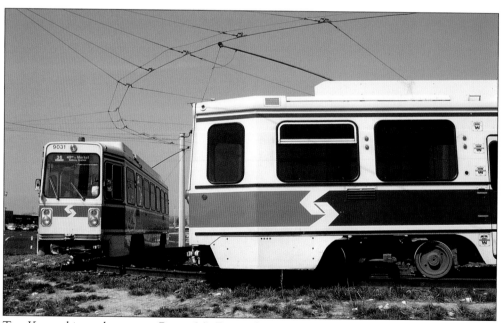

Two Kawasaki cars lay over at Route 36's Eastwick Loop in 1987. The loop is adjacent to a busy shipping plaza, which contributes to the line's ridership. (RCDM.)

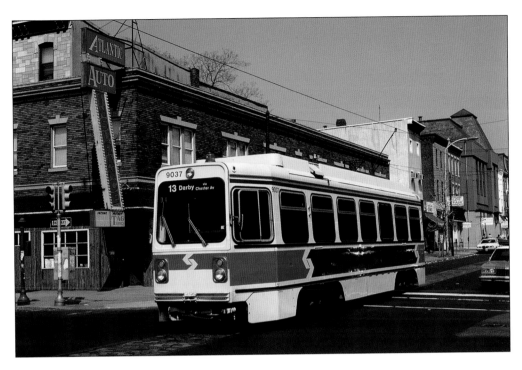

Diversion tracks around 40th Street are used for special operations, usually when the trolley subway is blocked or closed. The image above was captured at 40th and Chestnut Streets. Below, a Route 34 car turns from Baltimore Avenue onto the diversion trackage at 42nd Street. Both are May 1987 views. (Both, RCPTM.)

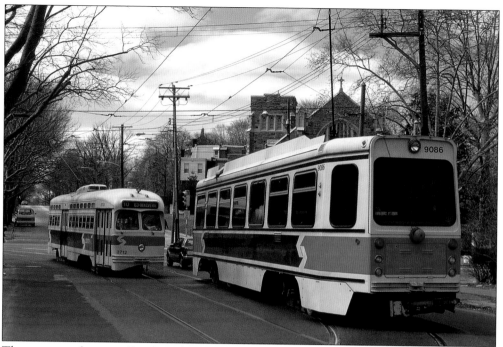

The new cars also are taller than their predecessors, as 9086 demonstrates while approaching a PCC car outside Route 10's Malvern Loop in April 1987. (RCDM.)

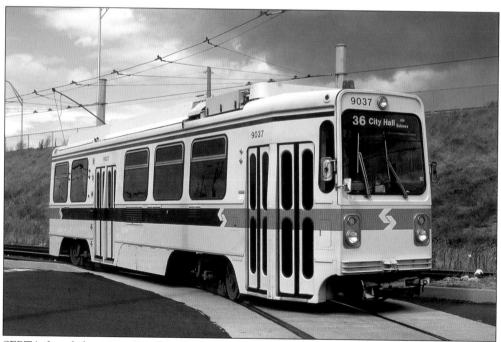

SEPTA found the original wide color band hard to maintain and gradually repainted the new cars in a simplified narrow-band scheme that also was used on some of the rebuilt PCC cars. One of the repainted Kawasaki cars approaches Route 36's Eastwick Loop under cloudy skies in 1988. (RCPTM.)

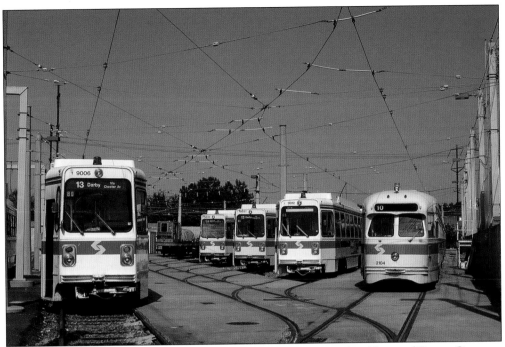

PCC cars had become a footnote by the time of this 1993 photograph at Elmwood Depot. Compare the scene with the 1982 image on page 30. (RCDM.)

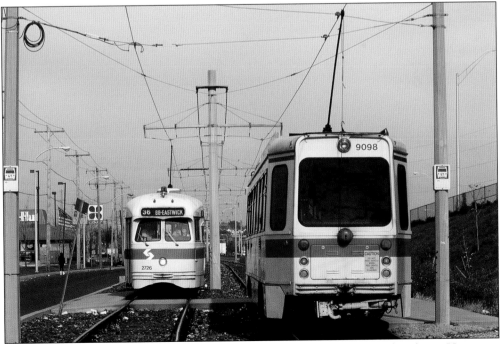

The outer end of Route 36 along Island Avenue operates on private right-of-way. Here, two generations pass near Penrose Plaza in 1995. (RCPTM.)

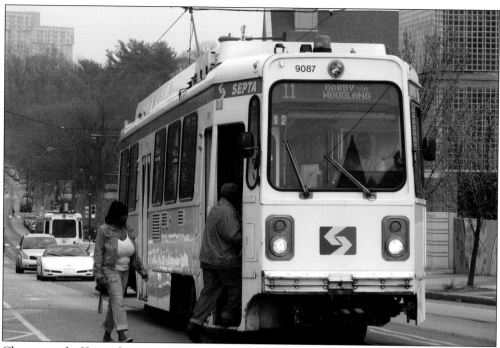

Changes to the Kawasaki cars over time have included a third and simpler paint scheme, electronic destination signs, and fully sealed windows. Car 9087 picks up passengers on Woodland Avenue in 2012. (RD.)

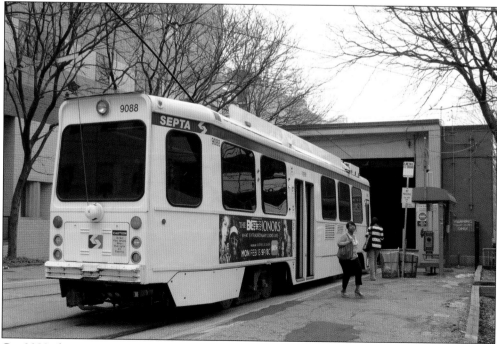

Car 9088, showing its single red and blue roofline stripe, prepares to dip into the Route 10 subway portal in 2012. High-rise buildings now surround the area, which is also seen on page 18. (RD.)

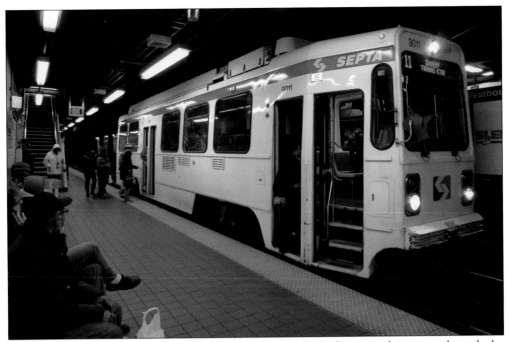

The West Philadelphia routes have survived by giving riders a fast route downtown through the trolley subway. This is the westbound platform at 30th Street. (RD.)

Of all the subway stations, only 19th Street still retains some of its early-20th-century feel with ceiling pillars and vintage tile walls. (RD.)

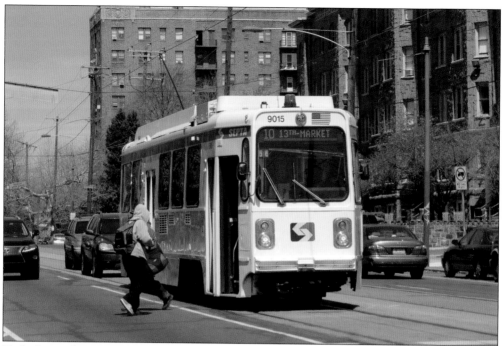

High-density housing grew up around many Philadelphia trolley lines, as on Route 10 along 63rd Street. (RD.)

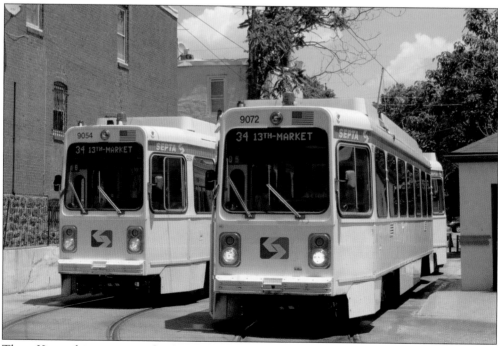

Three Kawasaki cars wait at the 61st Street and Baltimore Avenue Loop of Route 34 on Father's Day 2016. Car 9054 had been chartered by Friends of Philadelphia Trolleys, while the other two vehicles were in regular Sunday afternoon service. (RD.)

Three

GIRARD AVENUE RENAISSANCE

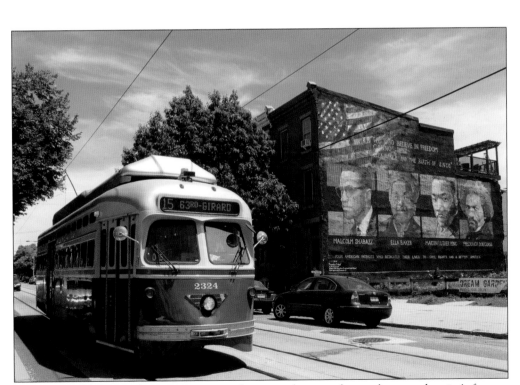

Three Philadelphia traditions are captured in one photograph: row houses, the city's famous murals, and trolley cars. Service returned to Girard Avenue in 2005 following Route 15's temporary conversion to buses in 1992. (RD.)

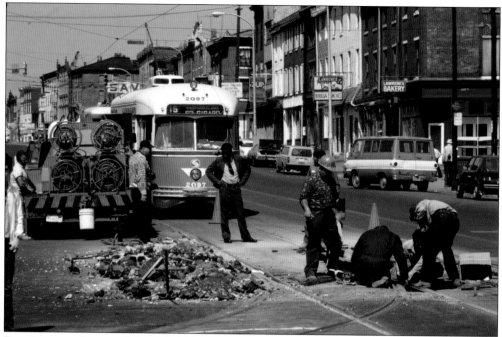

Repairs around a switch have held up eastbound car 2097 at Girard Avenue and 4th Street in the late 1970s. Trolley fans with cameras are enjoying the delay, but the operator looks exasperated. (JS.)

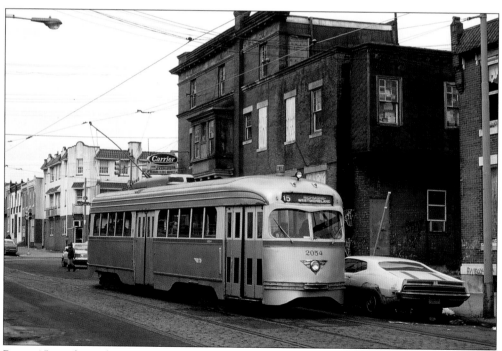

Route 15 cars have their western layover point at Girard Avenue and 63rd Street, where 2054, in re-created 1938 colors, pauses in 1982. (RCDM.)

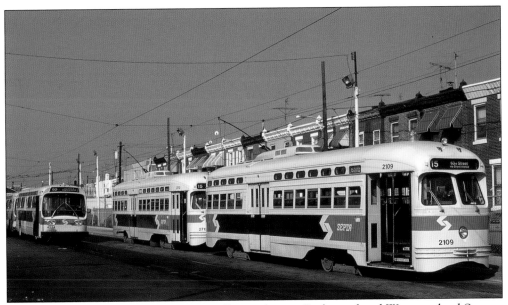

The eastern terminus of Route 15 is an off-street loop at Richmond and Westmoreland Streets. It is shared by Route 60, which became a bus line in 1977. Both transit modes are seen sharing the space in 1983. (RCDM.)

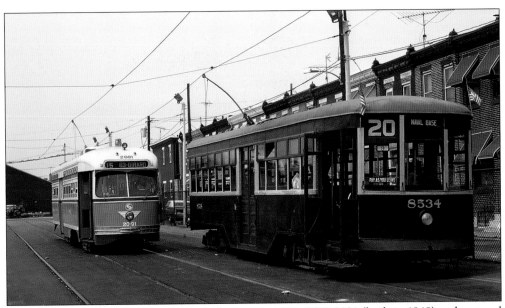

Two generations of streetcar are seen at the loop in 1979: PCC 2091 (built in 1948) and restored Peter Witt car 8534 (1926) on a fan trip. The Peter Witt car takes its name from the Cleveland transit official who pioneered the design in the 1910s. (RCDM.)

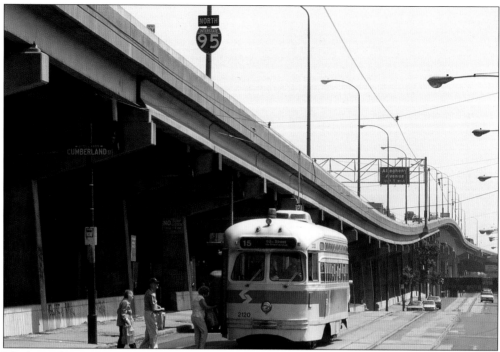

The heat of a summer morning hangs in the air as car 2091 stops for passengers at Richmond and Cumberland Streets, beneath Interstate 95, in July 1992. (RCDM.)

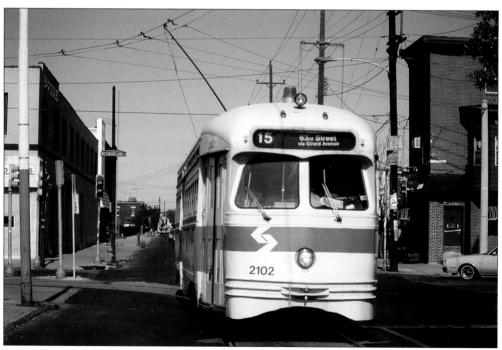

Car 2102 squeals around the curve onto Richmond Street to begin another westbound run in September 1992, the month SEPTA replaced Route 15 trolleys with buses. (RCDM.)

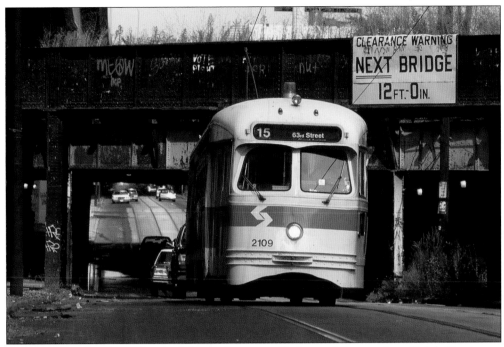

Weeds and graffiti abound around this underpass on Richmond Street, where Ralph Curcio was documenting the final days of PCC operation before buses took over. (RCDM.)

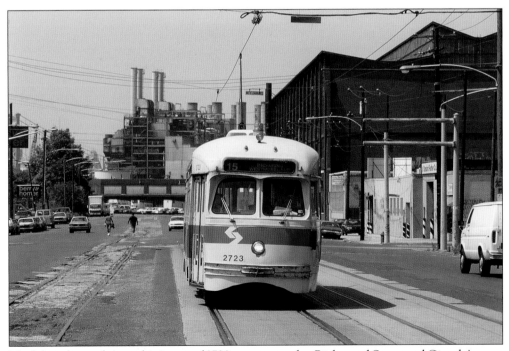

Much has changed since this image of 2723 was captured at Richmond Street and Girard Avenue in July 1992. The large brick factory structure at right is just a memory, while the trolley tracks have been rebuilt and repositioned. (RCDM.)

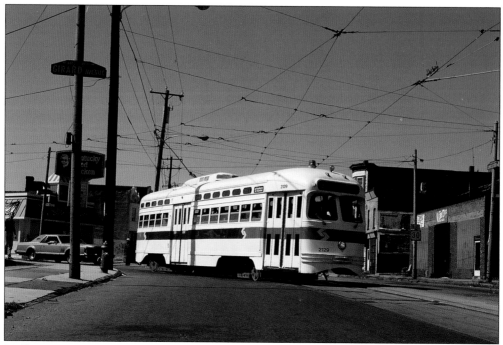

Trolley routes 10 and 15 come together on Lancaster Avenue, where Girard Avenue cuts across at an odd angle. The junction is seen in September 1992, with car 2192. (RCPTM.)

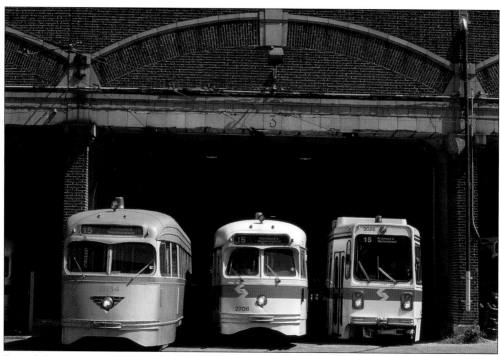

From left, veterans of 1941 and 1947 are joined by a relative newcomer from 1981 at Callowhill Depot as trolley fans gathered to mark Route 15's changeover to buses in 1992. (RCDM.)

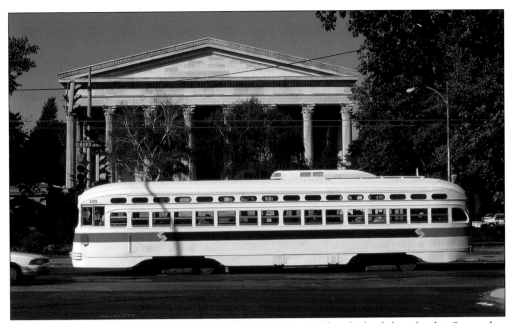

Girard College's Greek Revival Founders Hall (built 1833–1847) is the backdrop for this September 1992 image. The building is listed as a National Historic Landmark. (RCDM.)

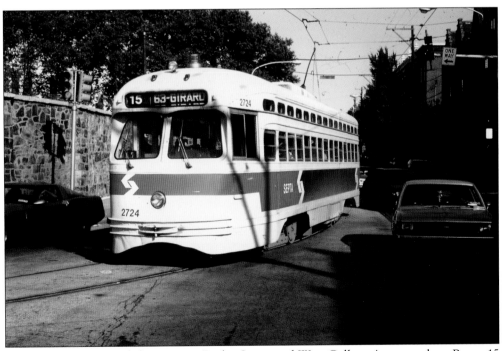

Car 2724 swings around the curve at Poplar Street and West College Avenue, where Route 15 skirts the Girard College campus, in September 1992. (GLR.)

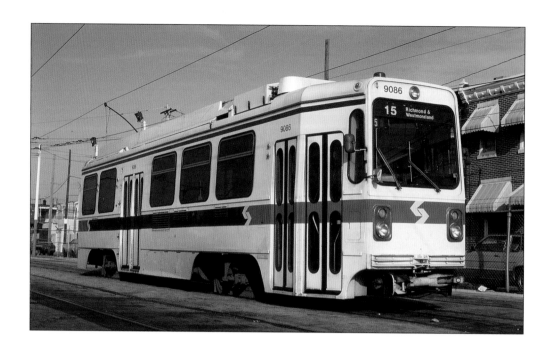

Kawasaki cars have been known to operate on Route 15 on occasion, both during its original run and at times during the 1990s when it was officially a bus route. These July 1992 photographs show the cars at Richmond-Westmoreland Loop (above) and at Richmond and Clearfield Streets (below). (Both, RCDM.)

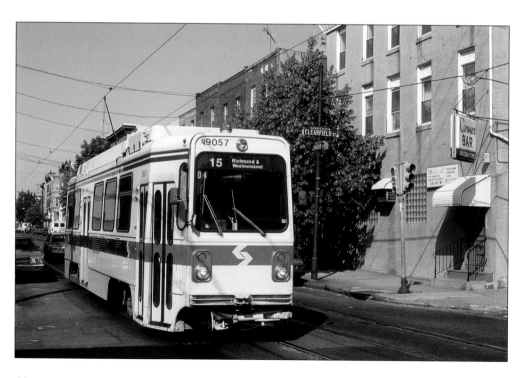

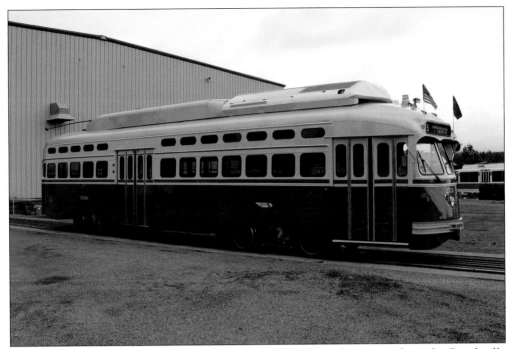

A new era dawns as PCC-II car 2320 (formerly 2750 of 1947) emerges from the Brookville Equipment Company's western Pennsylvania plant in 2003 bound for Philadelphia. Route 15's reopening was delayed until 2005 due to a controversy over lost parking spots on 59th Street, where the line accesses Callowhill Depot. (BEC.)

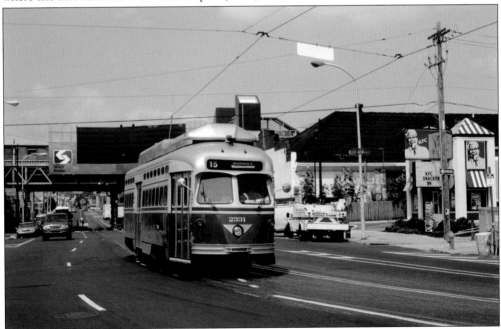

One of the busiest points on Route 15 is Girard Avenue and Front Street, where riders transfer between trolleys and the Market-Frankford rapid transit line, which is seen above eastbound car 2331. (RH.)

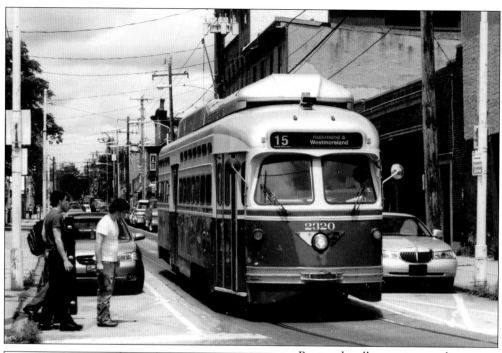

Restored trolley service was less than a year old when 2320 paused for three passengers at 26th and Poplar Streets in July 2006. (RD.)

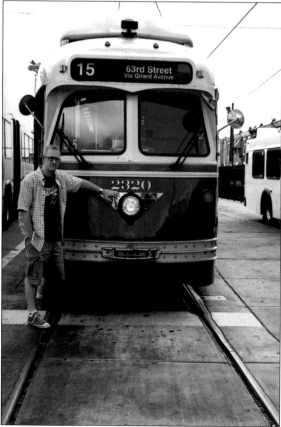

The author stands with the same car at Richmond-Westmoreland Loop in the summer of 2008, when the trolleys still carried traditional roller destination signs. (RD.)

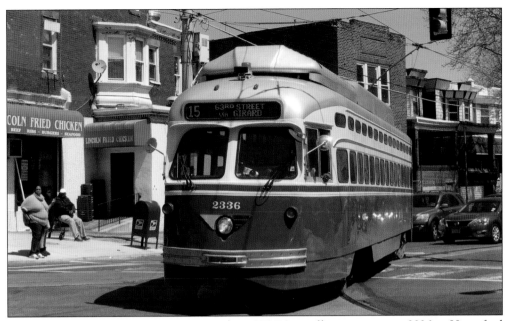

Electronic destination signs are now used on SEPTA's trolleys, as seen on 2336 at Haverford Avenue and 63rd Street. (RD.)

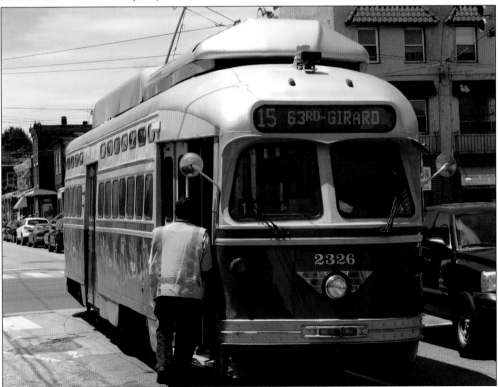

Trolley operators sometimes have to leave their vehicles for various reasons, including changing switches. They wear reflective vests for safety, as seen here at 63rd Street and Girard Avenue. (RD.)

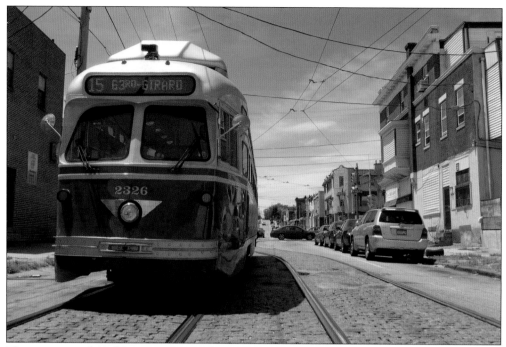

The area around 63rd Street and Girard Avenue has been spruced up somewhat since the gritty days seen on page 60. (RD.)

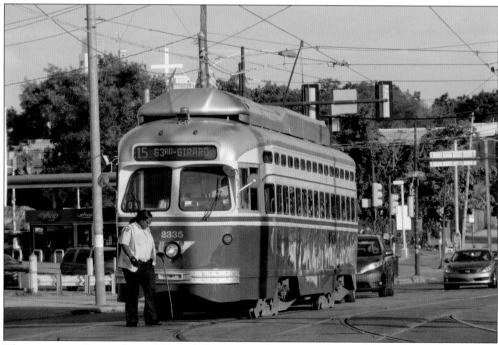

The operator of a westbound Girard Avenue car has stepped out of the vehicle to manually change a switch on Lancaster Avenue. Built as 2158, this car can be seen in 1970s colors on page 38. (RD.)

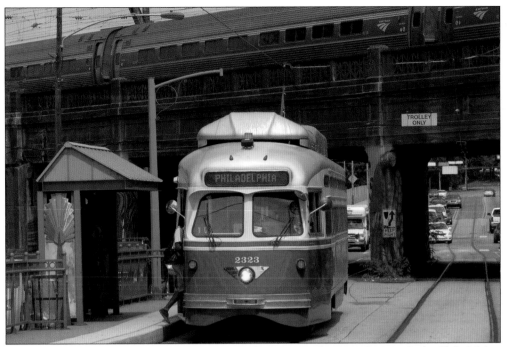

An Amtrak train thunders overhead as westbound car 2323 picks up a rider outside the Philadelphia Zoo in June 2015. (RD.)

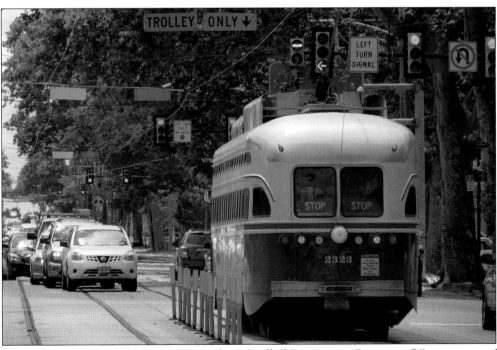

The entrance from Girard Avenue onto the Schuylkill Expressway (Interstate 76) is a source of congestion at busy times, with left-turning vehicles creating delays. (RD.)

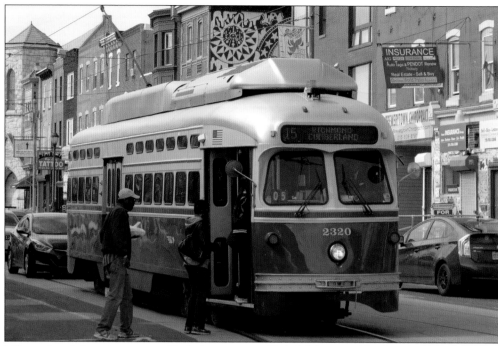

Vibrant local shopping areas still thrive in many Philadelphia neighborhoods, and crosstown Route 15 links many of them. This is Girard Avenue and 26th Street. (RD.)

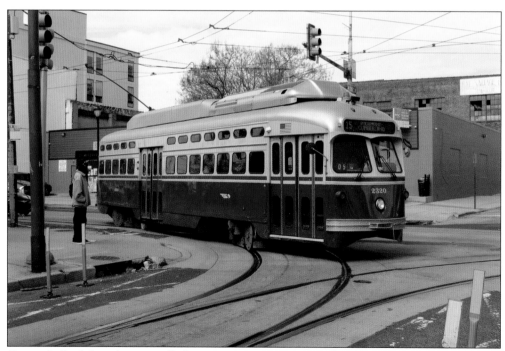

Orange bollards have been installed at many corners to prevent illegally parked cars from blocking the tracks where trolleys turn, as seen here at Girard Avenue and 26th Street. (RD.)

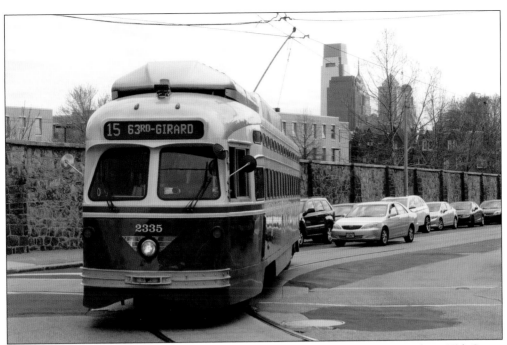

Philadelphia's skyline looms over the Girard College campus as car 2335 swings from 25th Street back onto Girard Avenue. (RD.)

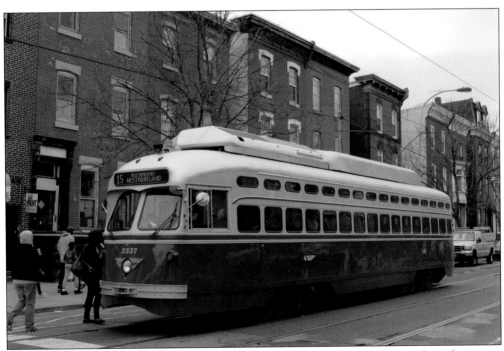

About 60 percent of Philadelphia residents live in some form of row house, such as those seen here along Girard Avenue near 19th Street. (RD.)

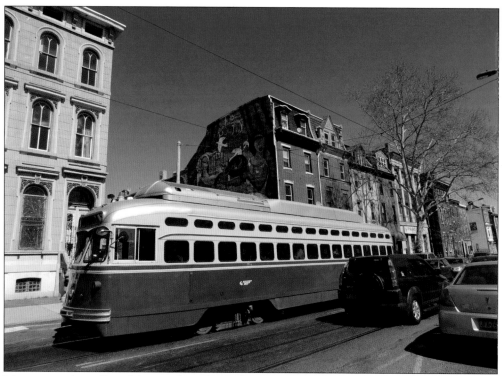

Many areas along Girard Avenue have been thriving residential and commercial districts since the 19th century, which is reflected in the architecture, as seen here at 16th Street. (RD.)

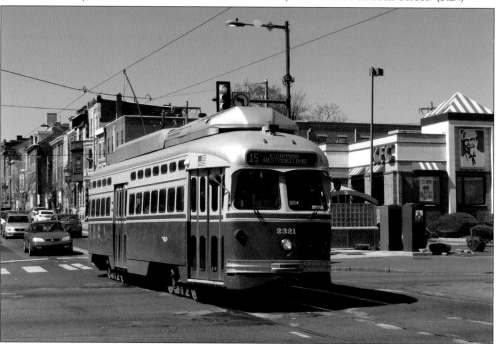

Girard Avenue and Broad Street is a busy stop where riders transfer between trolleys and the Broad Street Subway. One entrance to the subway is visible behind the trolley. (RD.)

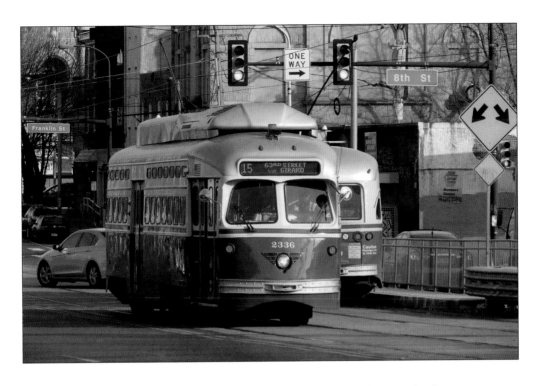

Girard Avenue becomes much wider east of Broad Street. These photographs show cars passing the stop at 8th Street, where safety islands are provided for trolley passengers to protect them from traffic. (Both, RD.)

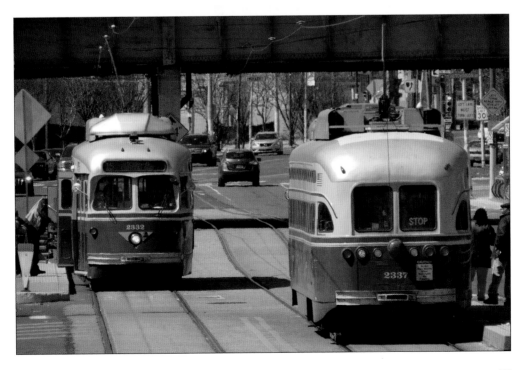

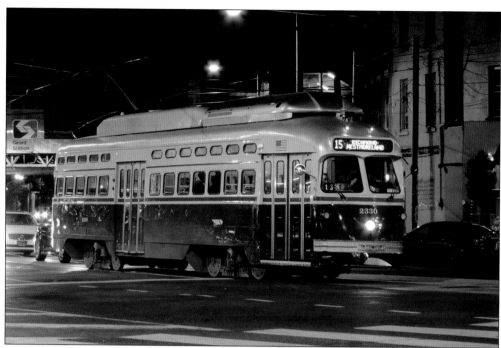

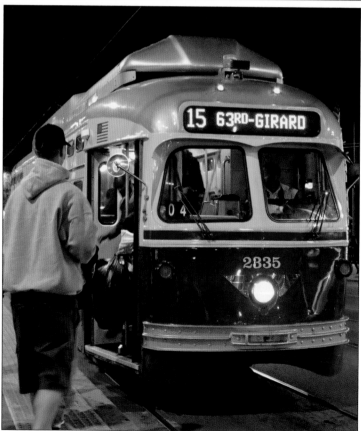

Philadelphia's Fishtown neighborhood has become a mecca for the young and hip, with bars, clubs, and restaurants creating vibrant nightlife, and Route 15 threads through hot spots such as Girard and Frankford Avenues, as pictured above. At left, the interchange between trolleys and elevated trains at Front Street is busy late into the night. (Both, RD.)

Four

SUBURBAN SCENES

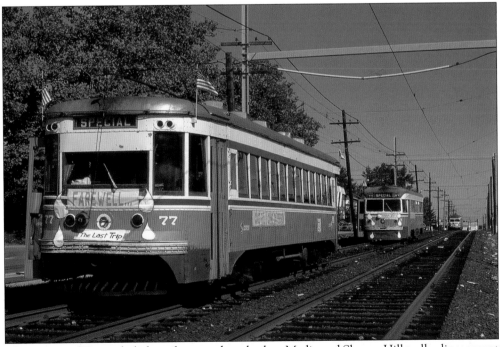

The coming of Kawasaki light-rail cars to the suburban Media and Sharon Hill trolley lines meant the retirement of former Red Arrow cars dating back to the 1930s and 1940s. A farewell excursion marked the occasion in October 1982. (RCDM.)

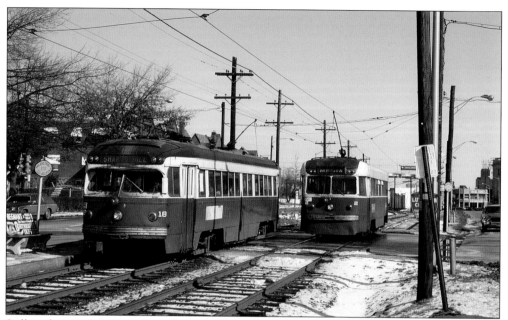

Still in their Red Arrow colors after six years of SEPTA ownership, cars 18 (built in 1949) and 2 (1941) pass at Walnut Street in Upper Darby in 1976. (RCDM.)

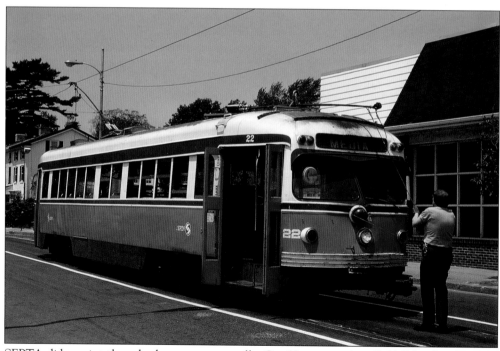

SEPTA did repaint the suburban cars eventually. Car 22 was wearing Gulf Oil colors by 1977, when the operator is seen changing the trolley poles on State Street, Media, after a trip out from 69th Street Terminal in Upper Darby. (RCPTM.)

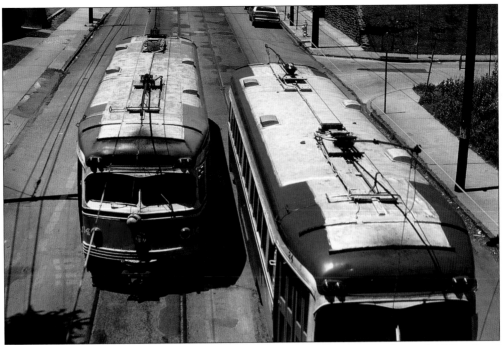

Two 1949 St. Louis Car Co. streamliners—similar to PCC cars—pass at Springfield Road and Jefferson Street in Clifton Heights on the Sharon Hill line in 1979. (RCPTM.)

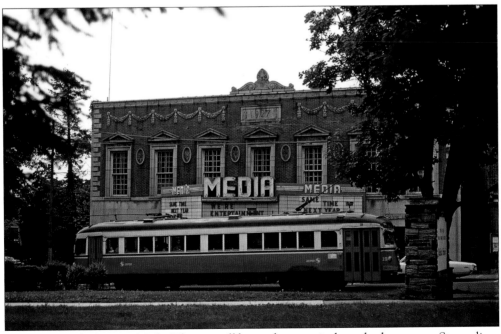

Built in 1927, the historic Media Theater still hosts plays, musicals, and other events. Streamliner 19 is seen passing the distinctive facade in 1979. (RCPTM.)

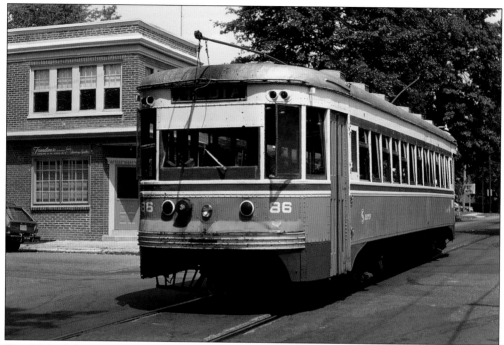

Car 86, built by Brill of Philadelphia in 1932, is seen at State Street and Manchester Avenue, Media, in 1982. It survives at the Middlestown and Hummelstown Railroad near Harrisburg, Pennsylvania, awaiting restoration. (RCDM.)

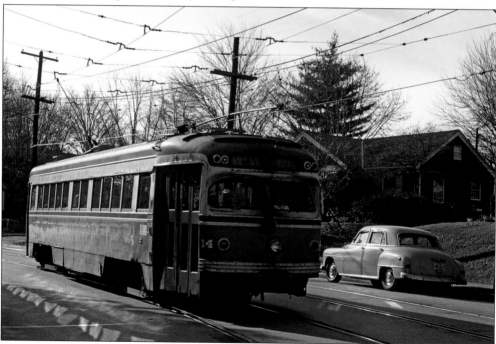

Streamliner 14 of 1949 passes a 1952 Plymouth Cranbrook in December 1981. The auto belonged to railfan Dan McFadden. The trolley can now be seen at the Pennsylvania Trolley Museum—and in chapter 5. (RCDM.)

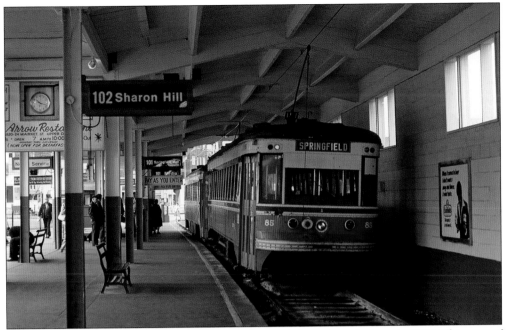

Vintage trolleys still called at the 69th Street Terminal departure platform in 1979. This area of the station has recently been rebuilt. (RCPTM.)

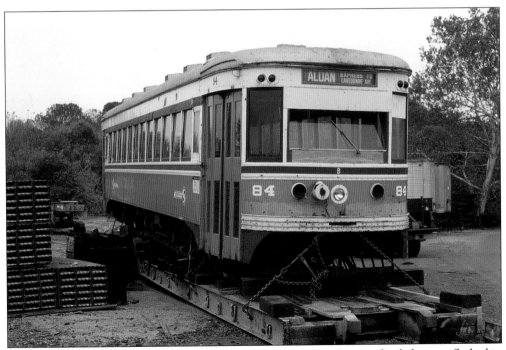

The Kawasaki cars displaced old Red Arrow trolleys such as car 84, seen loaded onto a flatbed in November 1982, the month after SEPTA ended use of the vintage suburban cars. (RCDM.)

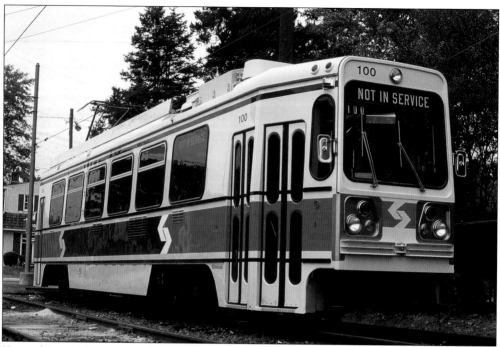

Kawasaki car 100 is seen during testing in October 1980, not long before entering revenue service. It had arrived from Japan in August of that year. (RCDM.)

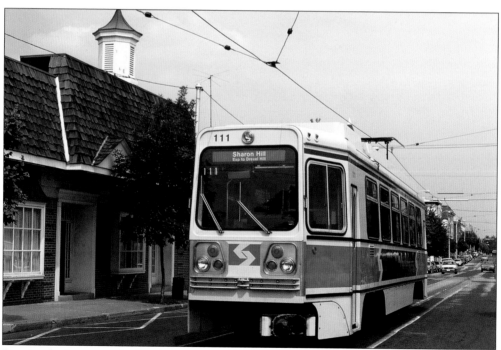

Despite the incorrect destination sign, car 111 is in Media, not Sharon Hill, in this June 1982 image. Like the city division Kawasaki cars, the suburban trolleys originally wore a wide color band on the sides, later replaced. (RCDM.)

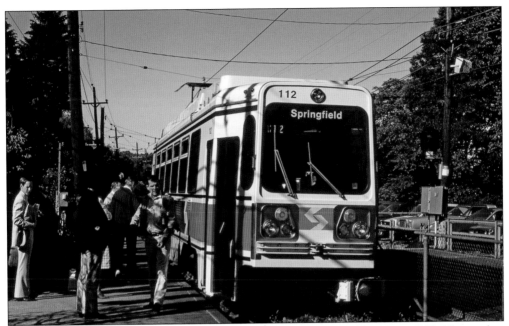

Car 112 waits for passengers at the Scenic Road stop in Springfield in June 1982. Notice that everyone is wearing slacks or a skirt, but no jeans or shorts. (RCPTM.)

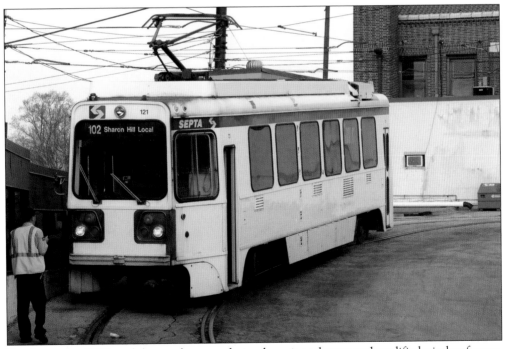

Fast-forward to 2012, and the cars have much simpler paint schemes and modified window frames, though the old destination signs have yet to be replaced by electronic models. Car 121 is seen on the loop at 69th Street. (RD.)

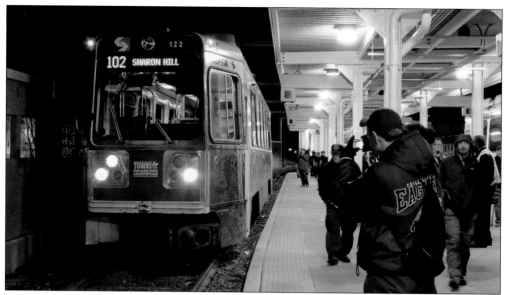

Railfans gathered for a 2015 New Year's Eve trolley charter at the remodeled 69th Street Terminal platform stop to admire car 122 and its temporary advertising wrap promoting suburban Philadelphia tourism. (RD.)

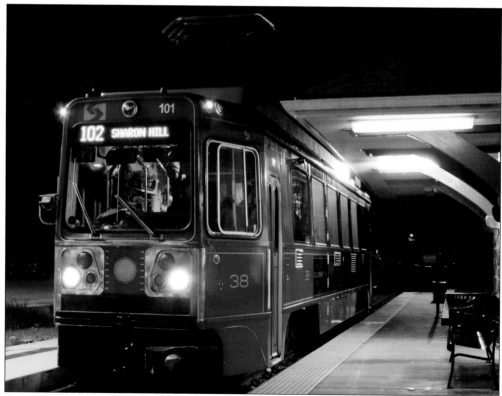

The charter used car 101, which featured a special wrap designed to resemble trolleys used on the line in the early 1900s. The wrap, which had been on the car for some time, has since been replaced. (RD.)

Five

SURVIVORS HERE AND THERE

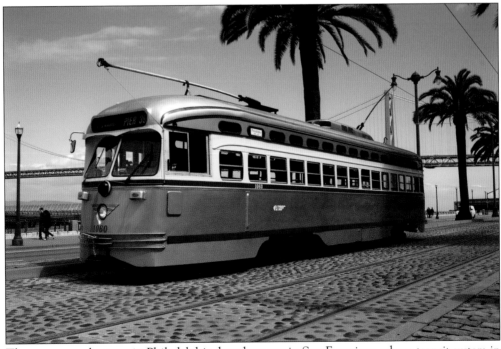

There are no palm trees in Philadelphia, but there are in San Francisco, whose transit system in 1992 bought 16 retired SEPTA PCC cars. They now wear historical paint schemes from many cities. Car 1060, formerly SEPTA 2715, carries 1938 Philadelphia Rapid Transit colors. (JMD.)

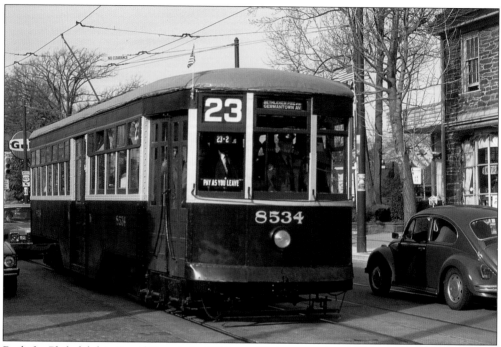

Built for Philadelphia Rapid Transit in 1926, car 8534 was used on charters in the city until the early 2000s. Here, it is seen in Chestnut Hill in 1978. (DM.)

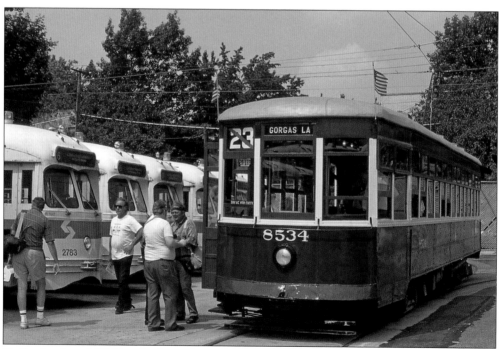

Trolley fans board 8534 beside a line of retired PCC cars at Germantown Depot in 1994. Today, 8534 is on static display at the Electric City Trolley Museum in Scranton, Pennsylvania. (RCPTM.)

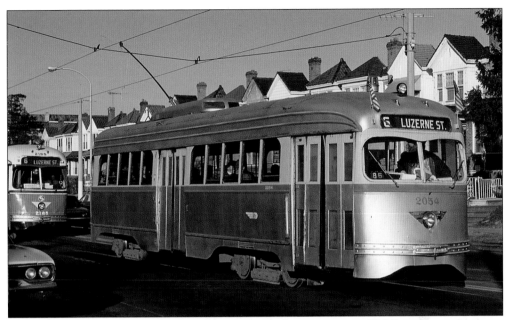

Car 2054 was painted in 1938 colors to mark the 40th anniversary of PCC operation. It is seen on the Route 6 farewell charter in 1986. Today, it is stored at the Electric City Trolley Museum in Scranton. (DM.)

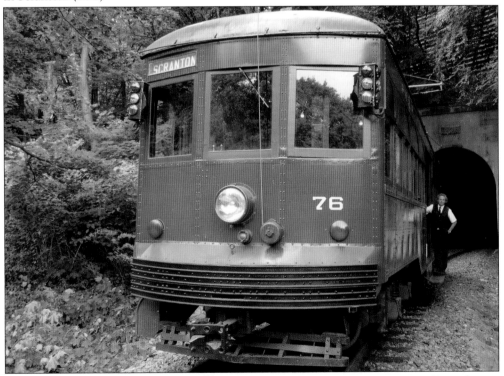

Many ex-Philadelphia cars reside at the Scranton museum awaiting restoration. But rides are given with two operational ex–Red Arrow trolleys—76, seen here outside the Laurel Line trolley tunnel, and 80. (RD.)

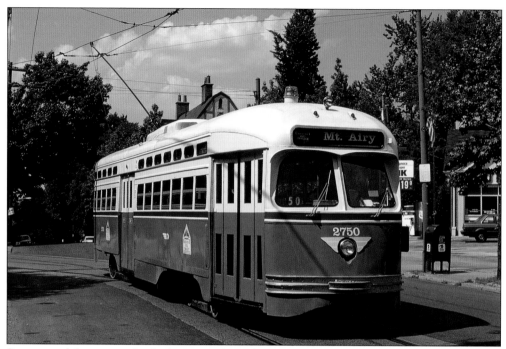

Streetcars did not completely disappear from the North Philadelphia lines in 1992. Charters and special services—such as the Chestnut Hill Trolley, seen here—and holiday trips continued intermittently. This car is now 2320 and runs on Girard Avenue. (RCDM.)

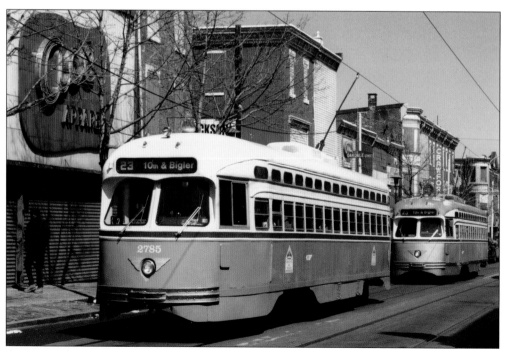

A two-car charter is seen on Germantown Avenue at Oakdale Street on Route 23 in 2002. The line's track has since been paved over in many places. (RD.)

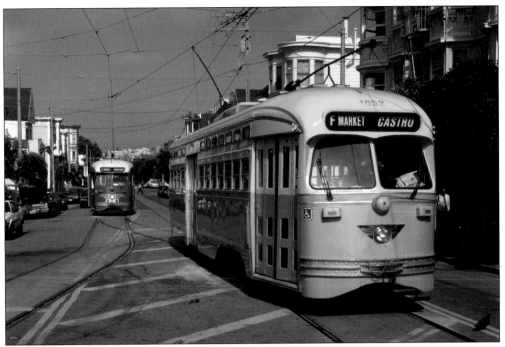

Ex-Philadelphia cars in Los Angeles Railway and Pacific Electric paint schemes are pictured in San Francisco in June 1996. (MS.)

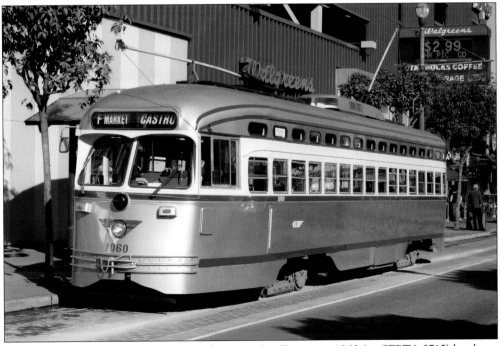

The 1938 blue, white, and silver paint scheme on San Francisco 1060 (ex-SEPTA 2715) has been dubbed "Philadelphia Cream Cheese" for its resemblance to the brand's packaging. (HAD.)

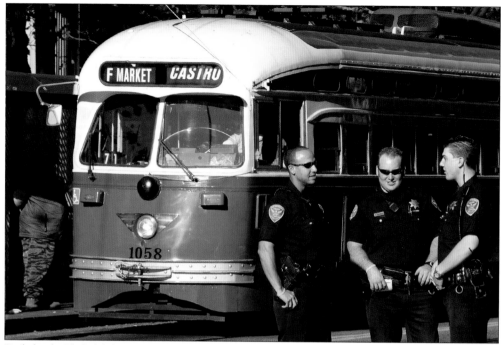

Built for the Philadelphia Transportation Company in 1948 as car 2124, this car was renumbered 1058 in San Francisco and has worn two historic color schemes formerly used in Chicago. (TH.)

Louisville, Kentucky, bought PCC cars but never placed them in service, converting to buses instead. This ex-SEPTA car commemorates them by wearing Louisville colors in San Francisco. (MS.)

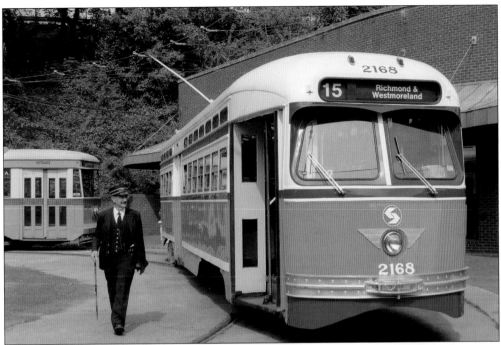

Friends of Philadelphia Trolleys (FPT), which supports preservation of cars in operating museums, funded the restoration of PCC car 2168 in 1970s Gulf Oil colors for service at the Baltimore Streetcar Museum in Maryland. It appears in an earlier guise on page 21. For more information about FPT, visit its website, Friendsofphiladelphiatrolleys.org. (Both, RD.)

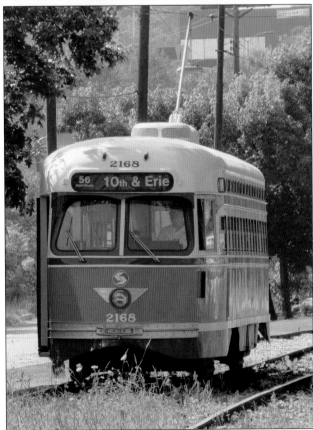

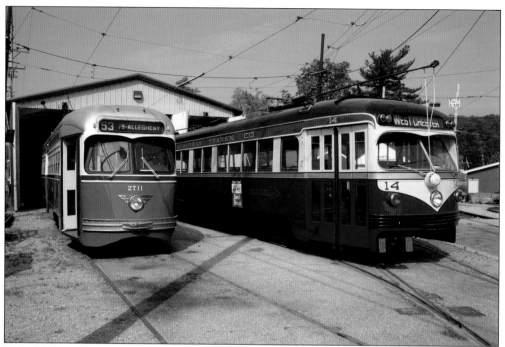

Philadelphia is well represented at the Pennsylvania Trolley Museum, located south of Pittsburgh. Here, streamlined cars from the city and suburban lines stand together in their original colors. (PTM.)

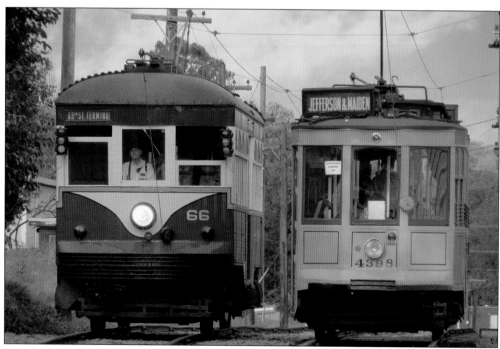

Another suburban Philadelphia car at the Pennsylvania Trolley Museum is Red Arrow 66, a sister to car 76, seen on page 87. Both date to 1926. It is seen passing a 1917 Pittsburgh car. (RD.)

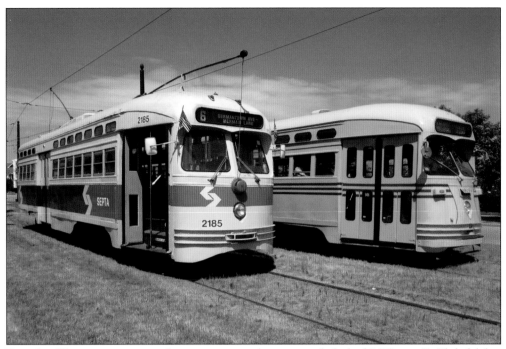

Kenosha, Wisconsin, operates a heritage streetcar line using refurbished PCC cars. Ex-Philadelphia 2185 is seen with a former Toronto car in the colors of Cincinnati, Ohio. (HAD.)

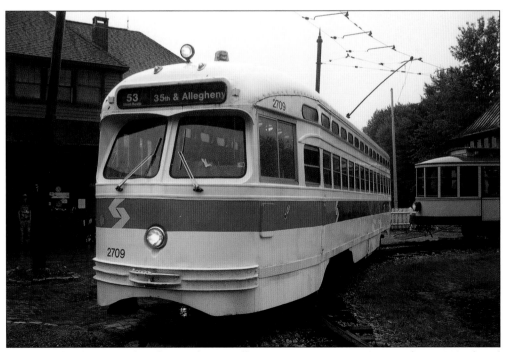

SEPTA 2709 is preserved at the Seashore Trolley Museum in Maine. A rainy day in 2004 found the car operating alongside a trolley from Minnesota. (MDC.)

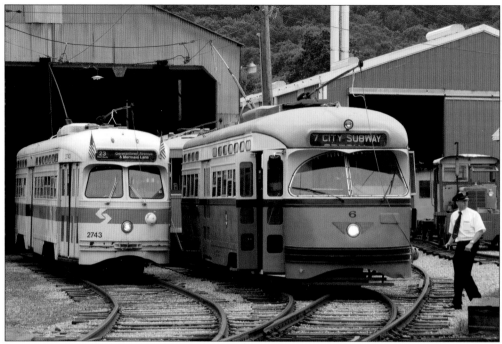

Car 2743 has resided at the Rockhill Trolley Museum in Huntingdon County, Pennsylvania, since 1994. It is seen at the museum in 2012 beside a Newark, New Jersey, PCC car. (RD.)

Friends of Philadelphia Trolleys has raised about $38,000 toward restoration of 2743 to its 1960s appearance. Exterior paint and body work were completed in 2015 by Star Trak, Inc., in New Jersey. The inside was being repainted and reupholstered seats installed in 2016. (HAD.)

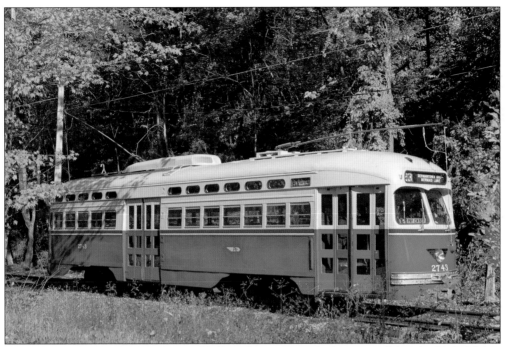

In 2015, car 2743 returned to the Rockhill Trolley Museum looking as it did under Philadelphia Transportation Company ownership. (BM.)

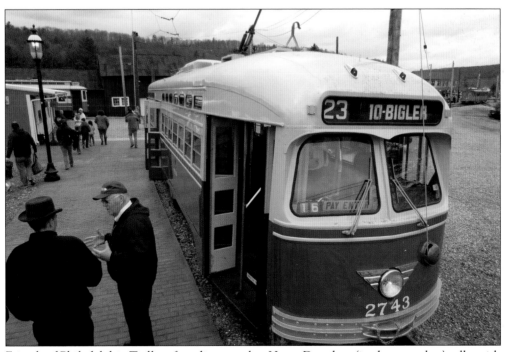

Friends of Philadelphia Trolleys founding member Harry Donahue (in the green hat) talks with a museum visitor about the history of car 2743. (RD.)

DISCOVER THOUSANDS OF LOCAL HISTORY BOOKS FEATURING MILLIONS OF VINTAGE IMAGES

Arcadia Publishing, the leading local history publisher in the United States, is committed to making history accessible and meaningful through publishing books that celebrate and preserve the heritage of America's people and places.

Find more books like this at
www.arcadiapublishing.com

Search for your hometown history, your old stomping grounds, and even your favorite sports team.

Consistent with our mission to preserve history on a local level, this book was printed in South Carolina on American-made paper and manufactured entirely in the United States. Products carrying the accredited Forest Stewardship Council (FSC) label are printed on 100 percent FSC-certified paper.

MADE IN THE USA